SELF-IMAGES
100 WOMEN
ANDRÉ RIVAL

Texts by

Klaus Honnef, Thea Herold, Georges Mara D'Ejove and Kristin Sauer

EDITION STEMMLE

Du Bleu, du Blanc, de la Vérité

Nous quittons l'Hôtel des Photographies, prenons
l'avenue de Friedland, passons à côté de Saint Augustin,
traversons les Grands Boulevards
et nous restons piégés dans les embouteillages de l'Opéra.
Notre intention est ferme.
Nous remontons une certaine rue Blanche, nous nous
dirigeons vers les quartiers chauds
du pied de la Butte.
C'est l'heure de l'attente de Saint Jean de Montmartre.
Sur le chemin qui mène du Bas vers le Haut,
nous portons la solitude à bout de bras:
Un peu plus de vérité quant au but, pense-t-il,
en prenant la pente de la rue Lepic.
Le tri des effets se tarit dans les faits,
il y a des touristes et des martyrs, là-haut, dis-je,
mais les gens ne se souviennent souvent pas,
répond-t-il. Il parle. Il parle d'elles.
De ce qu'elles ont pêché d'elles.
Elles.
Les apparences sont mortellement trompeuses, dit-il.
C'est le «mensonge qui dit toujours la vérité»:
qu'elle n'existe pas toute. Nous quittons la Butte.
Nous traversons de nouveau la ville,
mais dans le sens opposé.
L'important c'est que ce n'était pas facile,
dit mon ami sous l'ombre de la Très Grande Bibliothèque,
on ne fait rien, mais des photographies
se font quand-même. Tout est là au départ,
pas tout à la fin, quelque chose au demeurant insiste.
Reste. Il pleut.

Le Temps de l'Image serait le temps de l'attente,
pensais-je, le temps de l'imprévisible
rencontre de l'autre,
la mise à l'épreuve d'une promesse de bonheur,
photographique soit-elle,
par dessus le marché.
Nous passons à table. Nous buvons le nectar absolu
de Circé. Le Temps se disloque,
le sens s'élargit, l'image arrive, l'attente se fait courte,
se rétrécit mystérieusement.
Tard dans la nuit, un éclair perce le noir:
Des femmes dans un bain.
Sans eau. Bleu. Un sentiment d'inquiètude
s'empare soudain de mon ami.
Nous quittons la pièce éclairée.
Il fait les cent pas dans le couloir qui mène à la chambre.
Une femme passe, puis une autre, une autre encore . . . ,
une par une viennent, puis s'en vont.
La jeune fille rit, puis elle disparaît
dans le jardin. Je me précipite dans la pièce.
Blanc du petit matin.
Sur le seuil de la porte qui donne sur le couloir,
un livre. D'elles. Le texte s'arrête là:
Leurs images y imposent le leur.

Paris, le 16 Septembre 1994

Georges Mara D'Ejove

CONTENTS

K L A U S H O N N E F

" H U N D R E D W O M E N "

A P H O T O G R A P H I C P R O J E C T

One of the many cafés in the Montparnasse during the Twenties. Two young women obviously want to order, but the waiter refuses to serve them. Even their loud protestations fail to win him over. They weren't wearing hats, he said, and at that time women without hats sitting in public cafés were looked upon, even in Paris, as prostitutes. Man Ray, the great dadaist artist and photographer, observed the incident and described it in his illustrated biography entitled "Self-portrait". One of the two young ladies was Kiki, a model much sought after by the poor painters of Montparnasse who later gained worldwide fame; she soon became Man Ray's mistress and his favorite model as well.

He was forced to exploit his persuasive talents to the fullest, of course, before the young woman agreed to undress behind a screen in his studio. ". . . and then she appeared, modestly covering herself with her hand, looking exactly like the figure in Ingre's painting 'La source'".

The little drama in the Montparnasse strikes one as an endearing farce in contrast to the photographic project undertaken by André Rival. No longer is there an unwritten law that compels women to dress in a particular way – at least not in the societies that make up our western civilization. And a wink with the camera often suffices to attract models as if by magic.

Nevertheless – even at a time when all inhibitions seem to have been stripped off along with discarded clothing, when pornography rules almost unchallenged over the terrain of the erotic, rivaled only by the antiseptic sterility of fitness eroticism – a project such as Rival's is certainly a bold and unusual undertaking. He persuaded one hundred women to photograph themselves – for a book already planned. The sole condition: they had to be nude.

Such a notion is certainly not unusual in itself. In fact, it is standard practice for a certain species of magazines. What is unusual is the manner in which the photographer proposed to carry it out; for he specified only the externals of each and every photograph: By setting up the camera beforehand, he pre-determined the pictorial format. He also prescribed the spatial relationships operating within the setting. An empty living room served as a studio.

Its white walls provided the background, and the wood floors were also covered with a white material. Uncomplicated lighting ensured an evenly-distributed, shallow illumination. That changed only when the models moved in front of the immobile camera. In addition to the photographic equipment and the lighting source, a video camera and a monitor were placed in the room. The field of view shown on the video screen was nearly identical to that of the camera, thus enabling the models to control their photographic images rather precisely.

A few rectangular wooden or plastic pedestals, painted white, were the only props. Finally, André Rival made two further noteworthy decisions: to use a medium-frame camera and to photograph in color instead of black-and-white.

He was not present during the actual photographing. And therein lies the truly unusual aspect of his undertaking. Voluntarily, he bowed to the power of the one hundred persuaded women to stage their own photographs, purposely refusing to influence the process in any way – beyond the requirements he had already established. The choice of how they were to be portrayed was left entirely to the women. Within the pre-determined external framework they enjoyed total freedom.

For this as well was one of the pre-conditions: The photographer was not permitted to reject any of the photographs produced. That privilege was reserved exclusively for the models themselves. And it was not until photographer and model had arrived together at a selection of each woman's photographs that Rival showed his respective protagonists the pictures of the others.

It would have been entirely understandable had he, despite his youth already an experienced photographer able to look back upon a considerable number of publications, chosen his models from the immediate surroundings of his discipline – professional photo models or actresses. But this was precisely what he did not want. On the one hand, using only professional models would have increased his influence upon the results of the photographic experiment immeasurably. When they know a photographer, they offer exactly the repertoire he is looking for to begin with. On the other hand, Rival originally envisioned something more than a photographic experiment. His intent had been to provide, in a comprehensible visual form, a representative analysis of female behavior in front of the camera, a contribution, so to speak, to human behavioral research. This explains the unusual role-play he devised. The fact that he required his models to pose naked before the camera is less the expression of erotic and sexual desires than of his concern for authenticity. The view behind the mask of clothing. Nothing but the truth, the naked truth.

The photographer soon realized that he had set his sights too high. Without employing the precise scientific instruments of statistics and survey methods he could never have achieved a reliable statement. And the cost in time and effort would have been immense – any gain in insight into the complicated mechanisms of human behavior, on the other hand, relatively slight.

Thus Rival limited the number of participants in his experiment to a manageable quantity. And the longer he worked on the project, almost a year in all, the more clearly he recognized that he was faced with a very specific photographic challenge, a challenge from both a professional and an aesthetic standpoint. Didn't photography's early proponents speak of it, after all, with such enthusiasm as an artistic medium without an artist? A popular idea at that time was the image of a Raphael with no hands. It is no wonder that most artists categorically rejected photography for this very reason. At the same time, the conception of a kind of self-operating mode of artistic expression has always fascinated photographic theorists.

"For the first time", declared André Bazin in his brilliant essay on the "Ontology of the Photographic Image", "for the first time – in accordance with a strict determinism – an image of the external world is produced automatically, without the creative intervention of a human being . . . All forms of art are founded upon the presence of the human being. Photography alone takes advantage of its absence. It affects us like a 'natural phenomenon', like a flower or a snowflake, whose beauty is inseparable from its botanical or earthly origin". This noteworthy film critic finds credibility in photographic images, as the trend towards automation has led to the creation of an objective image and roughly shaken the foundations of psychology.

A "deed without a doer", is the term used by the essayist Martin Burckhardt with respect to photography. "Once exposed, the image develops entirely on its own, and the photographer is left with nothing but his role as a catalyst, one who fires the starting pistol, who turns on the ignition that sets the machine inside the black box in motion". Of course, someone like Man Ray saw things quite differently. ". . . I photograph like I paint, transform the model just as the artist does, and I could refine it or re-form it like a painter as well". Photography has attracted and crystallized a number of paradoxes around itself. In one way or the other all of the comments quoted here are related to them – an automatic process and to the same extent a technical instrument for artistic expression.

It is on the knife-edge of this notable contradiction, which may not, in fact, be a contradiction at all, that André Rival balances his no less notable project. He uses the possibilities photography offers, taking seriously their technical essence and in doing so accepts a role of lesser importance as an author or originator in the sense of craftsmanship and creativity. His seeming abstinence yields a remarkable harvest. Allowing the transformation of models into active participants, it levels the traditional hierarchical relationship between photographer and model, actually, the "photographic subject", and makes self-determining doers out of the potential victims of camera work – all within the prescribed framework, of course.

Additionally, Rival's voluntary renunciation casts doubt upon the carefully nourished myth according to which too many cooks spoil the aesthetic soup. In fact, he does nothing but exploit the emancipatory element in photography to the fullest. The aesthetic power of the series of photographs entitled "Self-Images: 100 Women", the impression of immediacy it conveys, its refreshing spontaneity, its often scalding irony and its astonishing honesty, expressive of latent anxieties – in short, the unbelievable diversity in the portrayal of human beings it presents are the products of the creative talents of each individual participant.

They came from a variety of social backgrounds, differed in age and occupation and obviously responded to the photographer's demand that they disrobe in front of the camera in very different ways. They also needed differing lengths of time, ranging from ten minutes to seven hours, to complete their tasks. Artists, several photo models, journalists, business-women, photographers, prostitutes, actresses, students, fashion designers, film-makers, advertising promoters, a retired woman and a saleswoman, a hatter, dancers and musicians, architects, movie producers, nurses, a speech therapist, a hairdresser – just a few examples of their occupations. It will probably not surprise anyone to learn that among the students, psychology majors were in the majority. Despite both the obvious and the less evident differences, however, all of the women shared one thing in common: self-assuredness; and none of them received payment for their contributions.

Their motives were as various as their physical features. Some were simply interested in a more intense experience. One of the protagonists wished only to take her picture – she didn't want to look at it afterwards, nor did she wish to see the photos of the other women.

An astonishing aspect is the wide spectrum of poses contained in the photographs. Open and hidden references to the arsenal of art history – to pictures by Ingres and Man Ray, for instance – and of commercial photography alternate with ironic citations and intentional provocations directed at the – male? – camera eye; alongside uninhibited pleasure in showing off one's own body we also find reticence in revealing one's self before an anonymous camera – in the knowledge, of course, that the photographs were to be published. Occasionally, carefully veiled fears come to the surface without warning. However, to give in to the temptation to interpret too quickly would be to venture onto thin ice. For most of the participants appear to have mastered the art of playing with and before the camera. What is authentic, and what is merely feigned? Is the woman who spreads her legs in apparent shamelessness really an exhibitionist, and is the next, shy and hesitant, a sensitive angel? Viewers must be on their guard, or phantasy will get the best of them. No one is in a position to form a definitive judgment about the women portrayed. They are playing roles, and not even the question of whether their reliance upon past models is conscious or unconscious can be answered reliably. This much, however, is clear: there is no clearly defined female image. Here as well, the watchword is pluralism.

And what of the problem of authorship? Was the project realized by the one hundred women whose names remain unknown? After all, the poses, the bodily and facial expressions, the use of props (most of them required more than the barren studio furnishings provided) and the chosen field of view was entirely their own work. And the photographer? Although merely complying fully with one of its principles, he conquered new terrain in the name of photography. He developed the idea for the project; he positioned the camera, prescribed the lighting, chose the models and took charge of the technical sequence of events. According to the aesthetic principles of Conceptual Art he is an artist. And according to the criteria of photographic aesthetics? These remain for the most part bound by the tenets of traditional art – which does not possess a nomenclature suitable for describing an undertaking such as Rival's. Nor are comparisons to cinematic art particularly helpful. Nevertheless, André Rival regards the finished work containing the self-images of 100 women as his own. And rightly so. Why? To explain would require us to develop, at long last, an independent aesthetics of photography.

References:

Man Ray, *Selbstporträt - Eine illustrierte Autobiographie*, Munich, 1983

André Bazin, *Ontologie des fotografischen Bildes*, in: *Was ist Kino*, Cologne, 1975

Martin Burckhardt, *Metamorphosen von Raum und Zeit: Eine Geschichte der Wahrnehmung*, Frankfurt/Main, 1994

KRISTIN SAUER

A Blending of the First Degree

The intimacy that lies beneath the surface
of my photograph might be obscene.
Not because of the nudity, or because phantasms
and phantasies come to light,
but because what is visible in the photo goes beyond me
to expose something else.
Something that I collide with that is beyond
the confines of my body. Something that both attracts
and repulses me. My "indecent" craving for it is so
strong that I am dazed by it.
For there in the picture in front
of me I see the experience of lust
for my own self.
The body my eyes observe is not exactly my perfection.
It is the representation
of the bewitching frailty of my fear
of abandoning myself.

When I reveal my most intimate nakedness,
I am separated from myself.
And only then can I lose myself in it again.
I long for that moment.
To me it seems an absolute excess and suddenly . . .
speechless.

I press the button. My image fixed,
I now belong to the viewer. Now he can see what lies
seductively there in waiting.

The experience of being viewer, subject and object
*at the same time, and yet **alone**,*
produces a wild confusion of whirling ideas.
It is simply wonderful to be so close to the impossible –
a sublime feeling.

PLATES

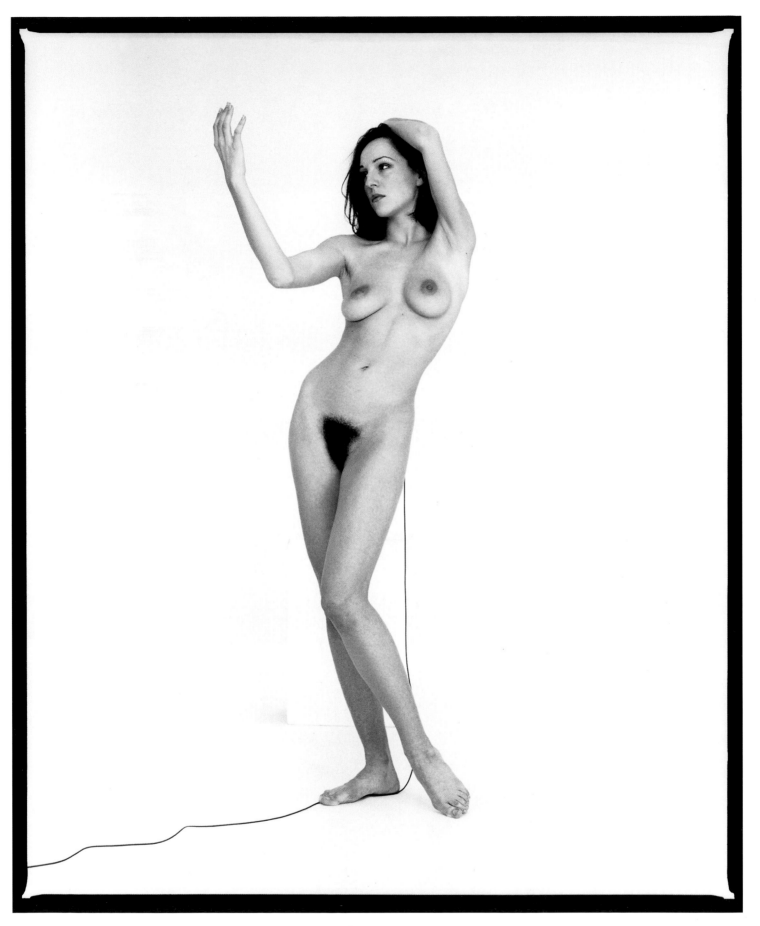

A L M U T

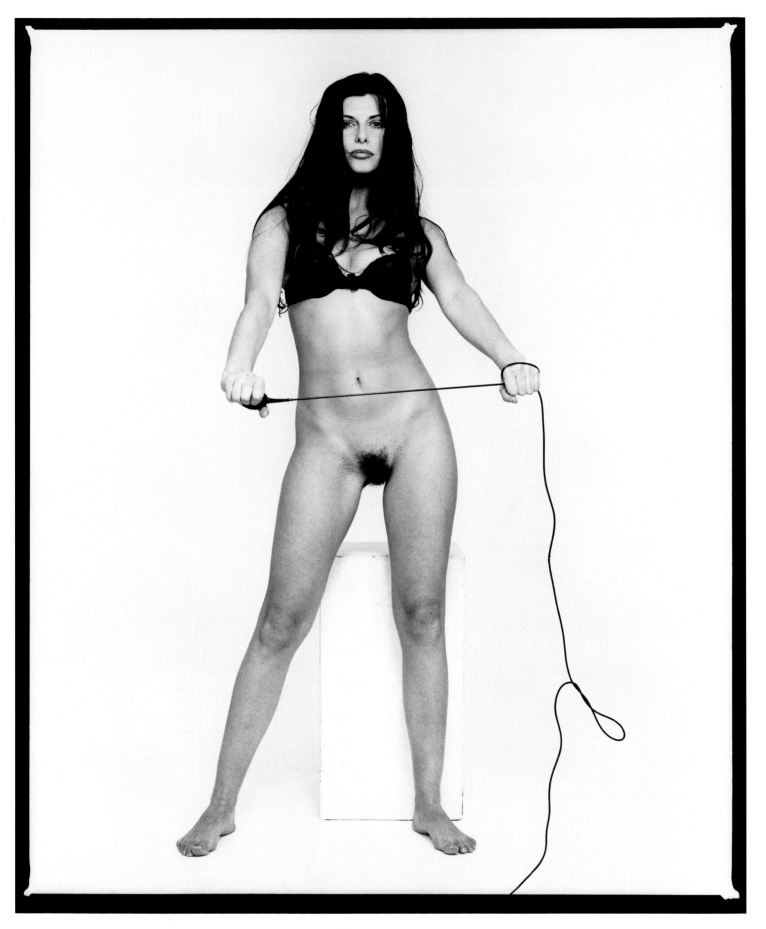

S U Z A N A

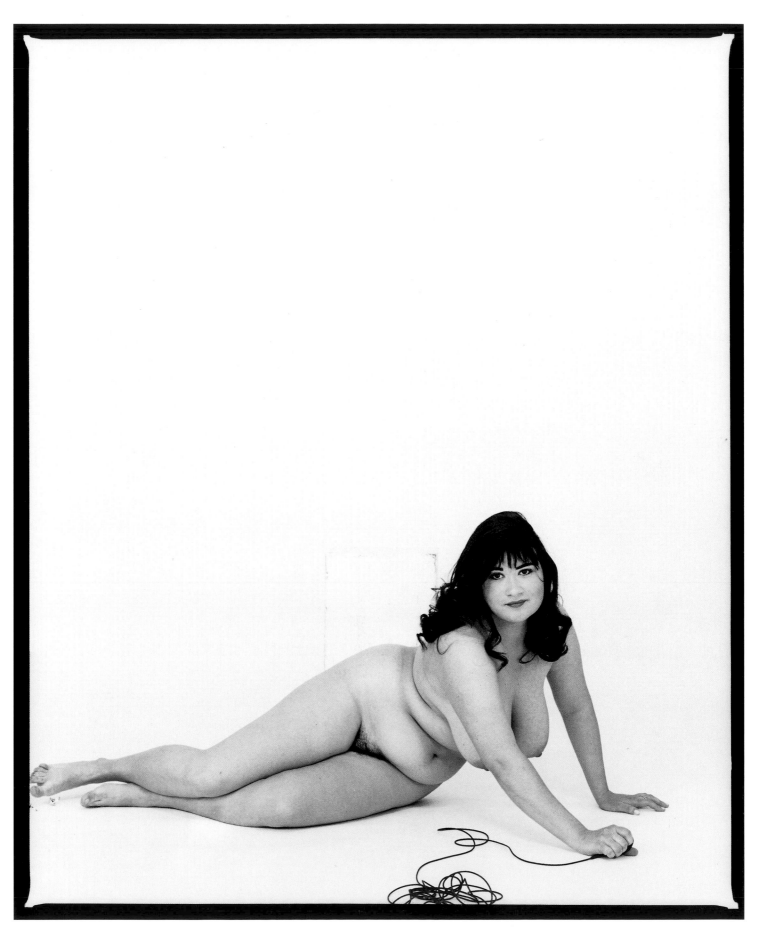

U T A

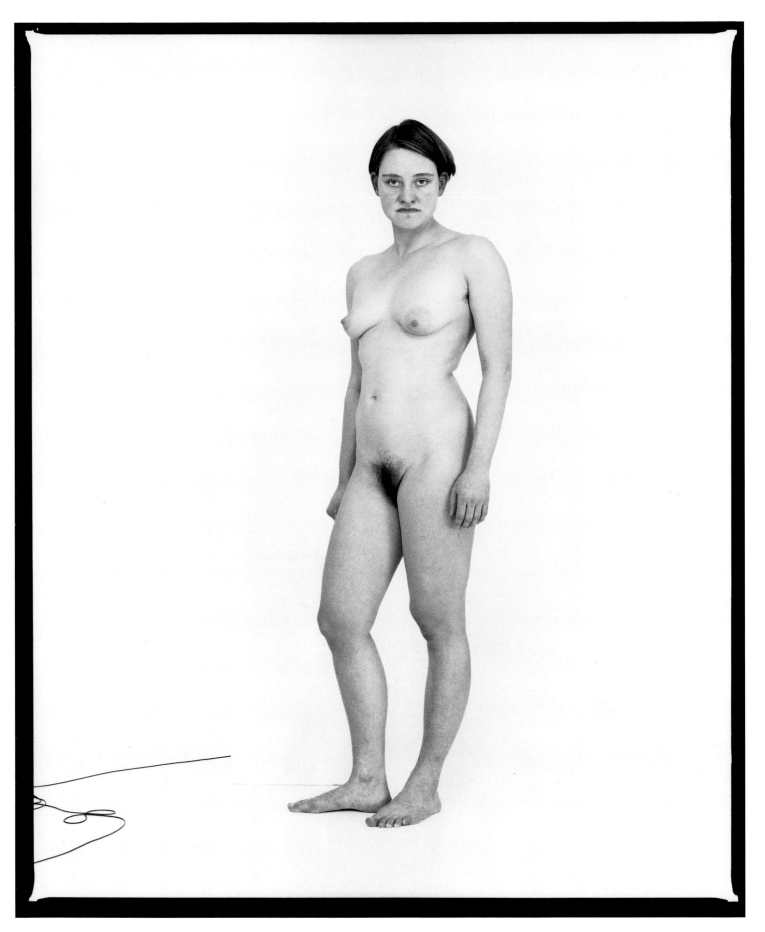

A N N E T T

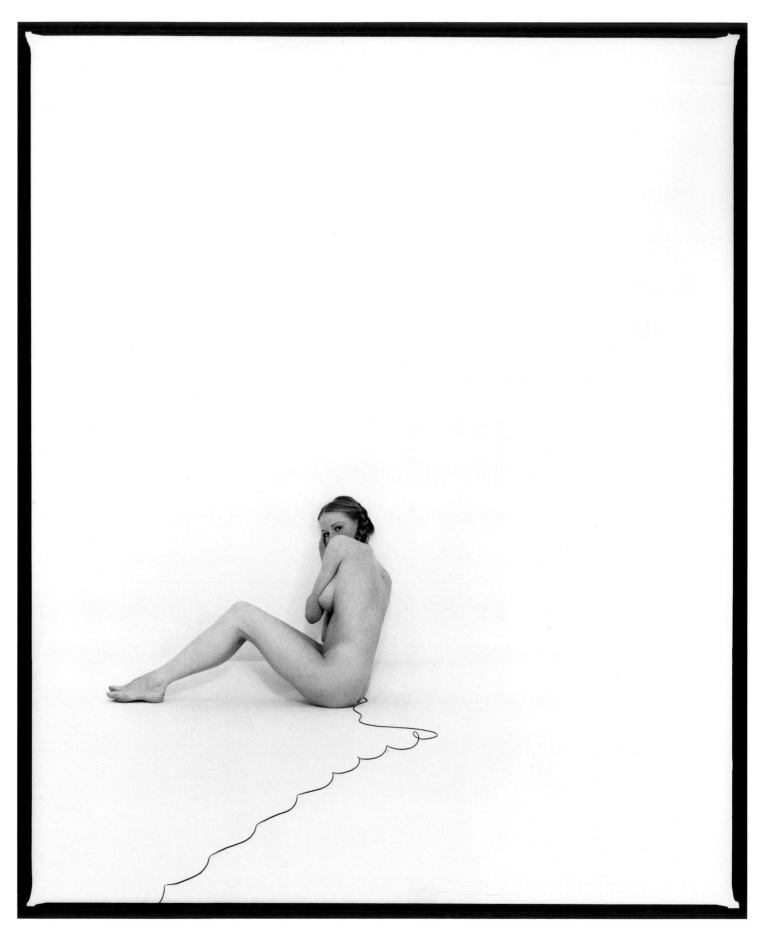

I R E N E

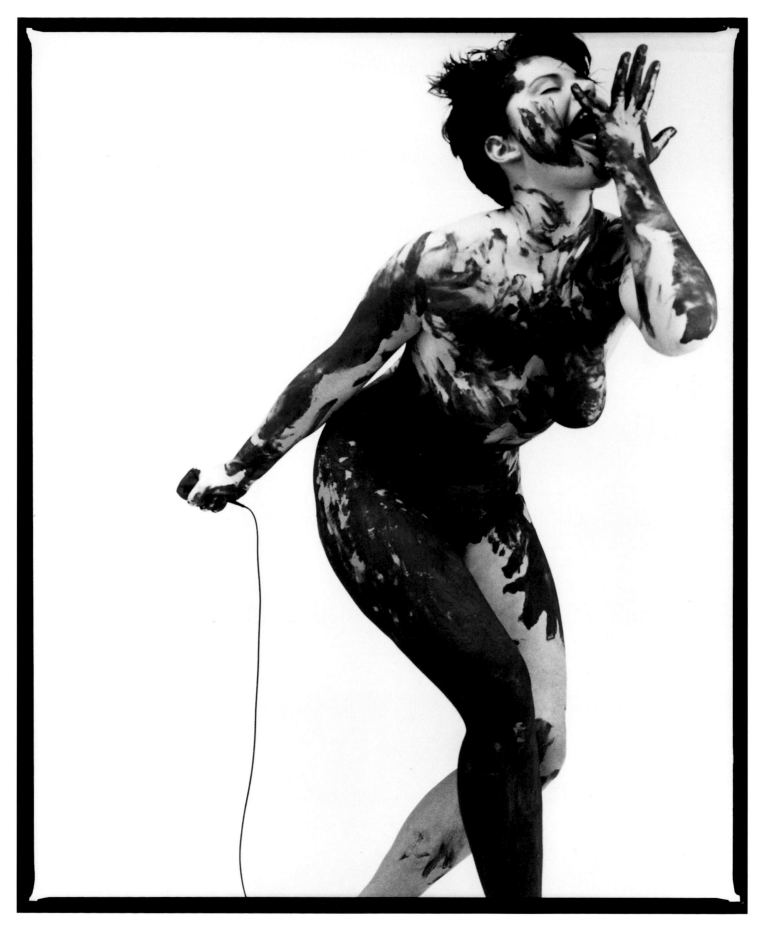

MAIKE

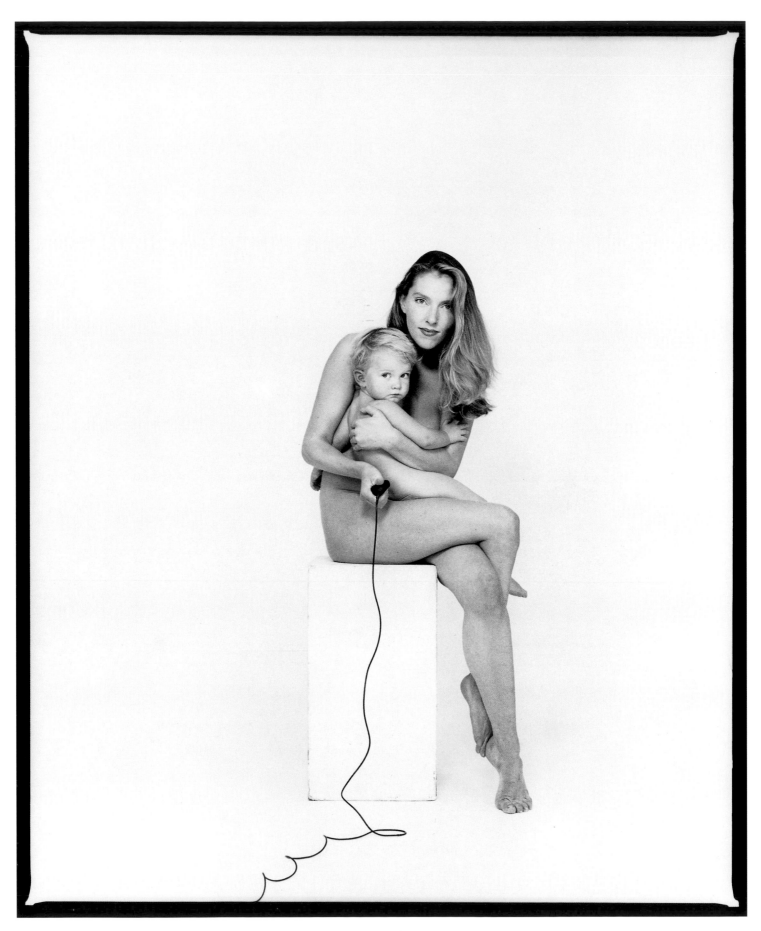

ANDREA, COSIMA

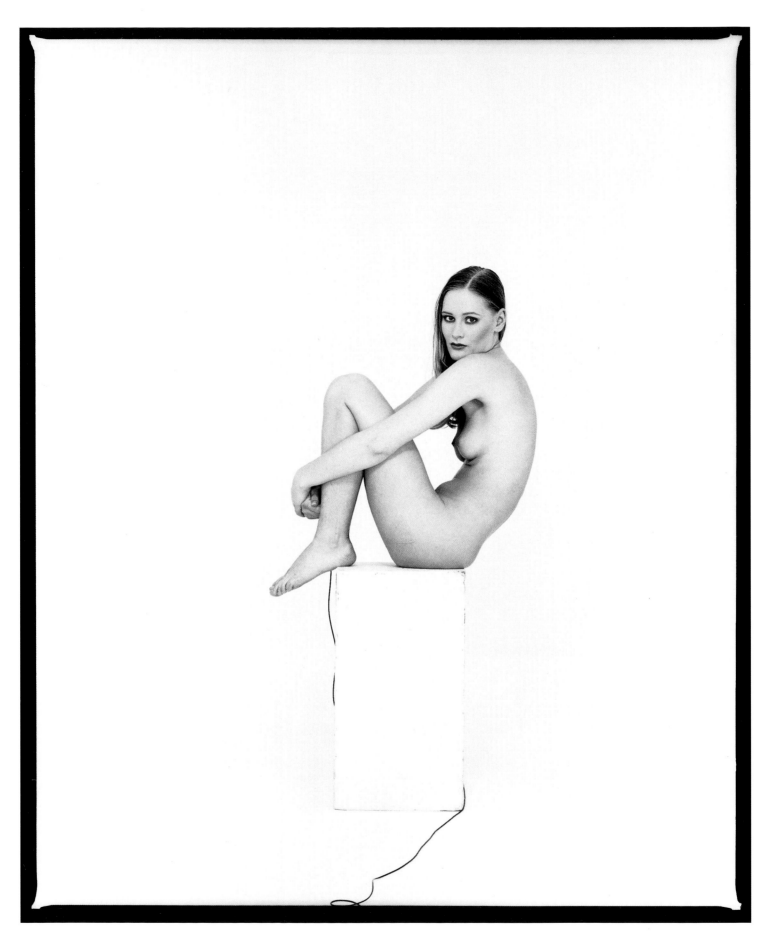

B E R I T

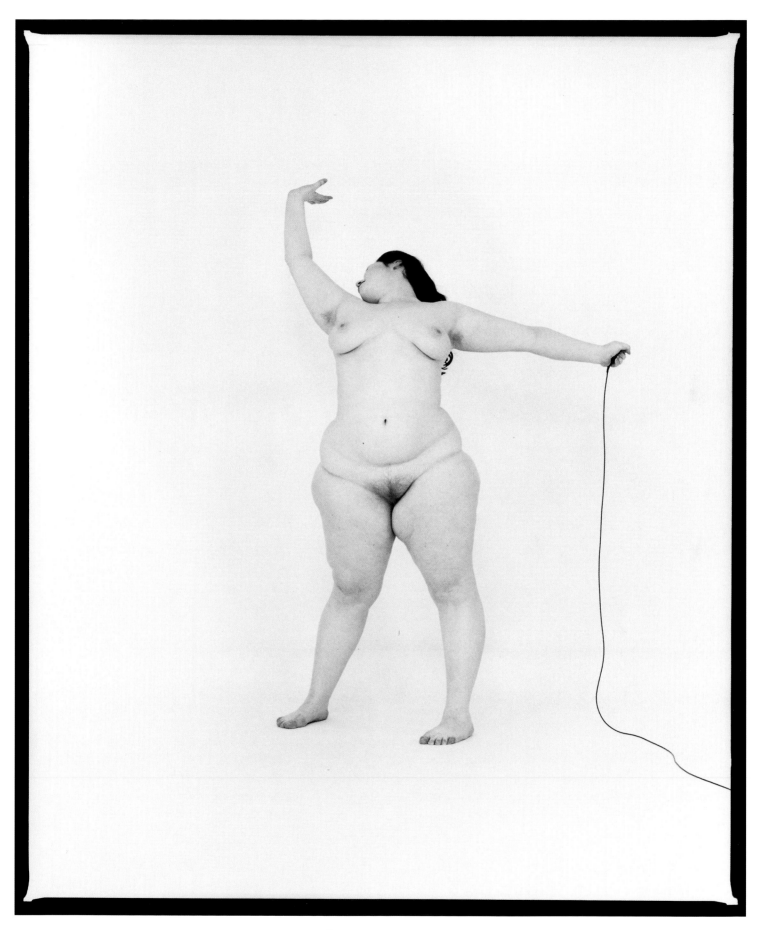

C H R I S T I N A

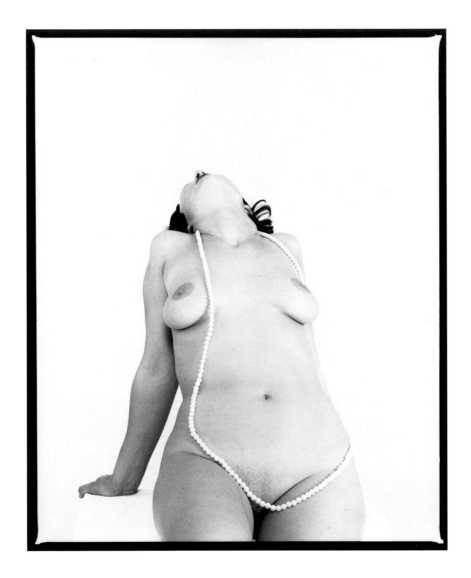

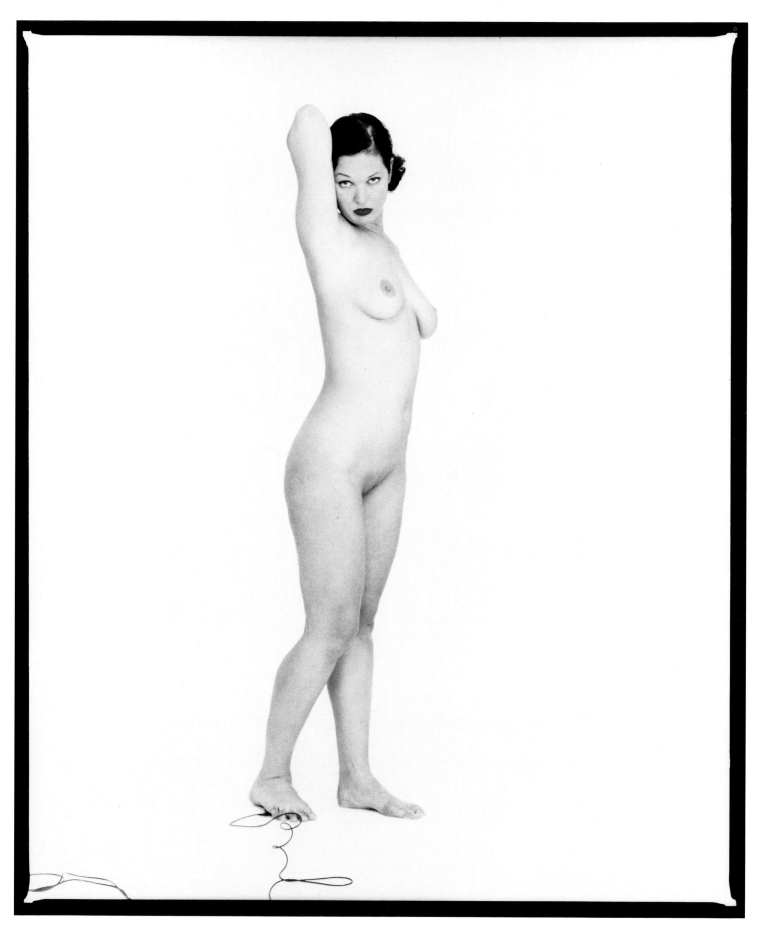

L A B A R B A R A

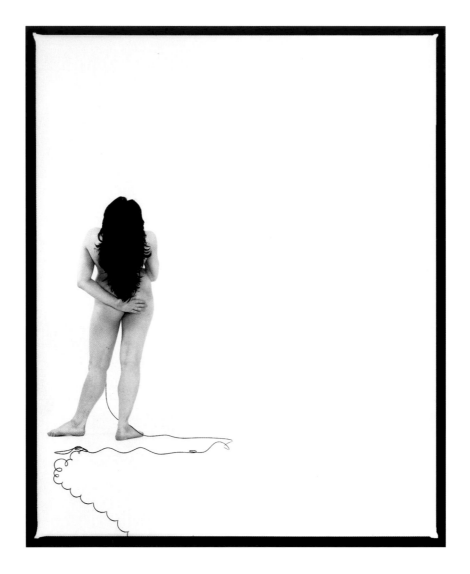

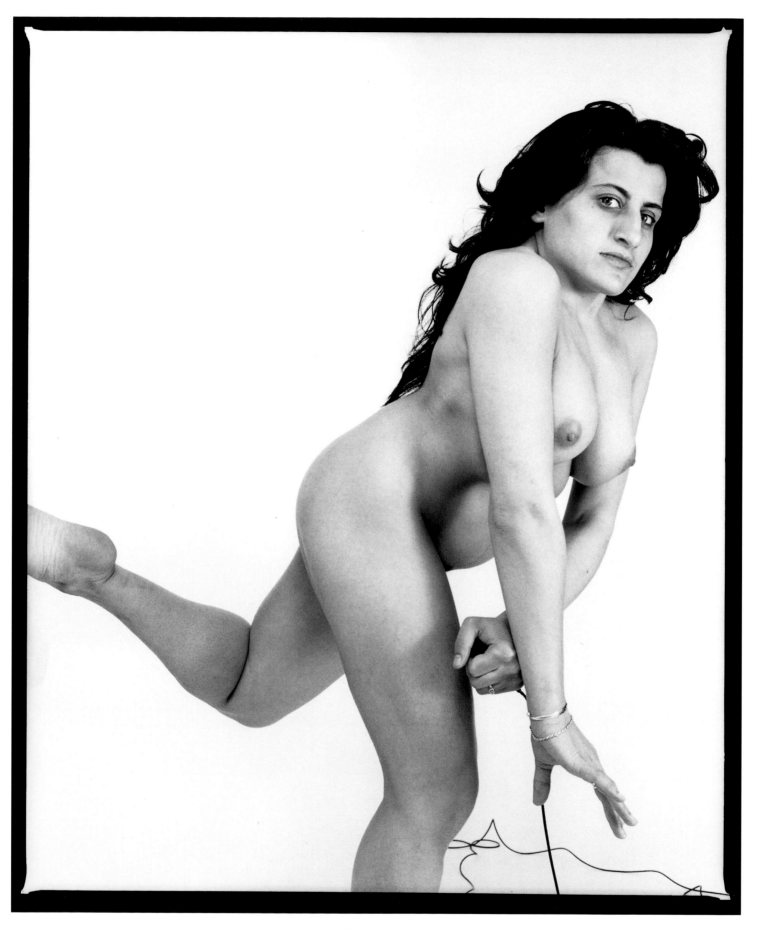

NIHAL

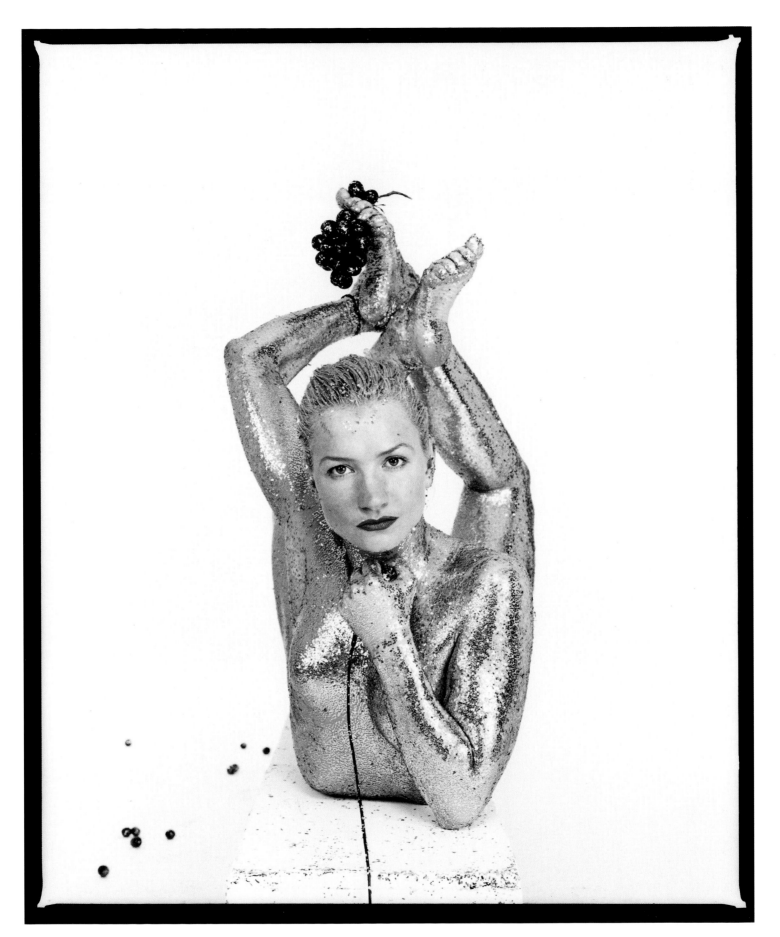

ROSE

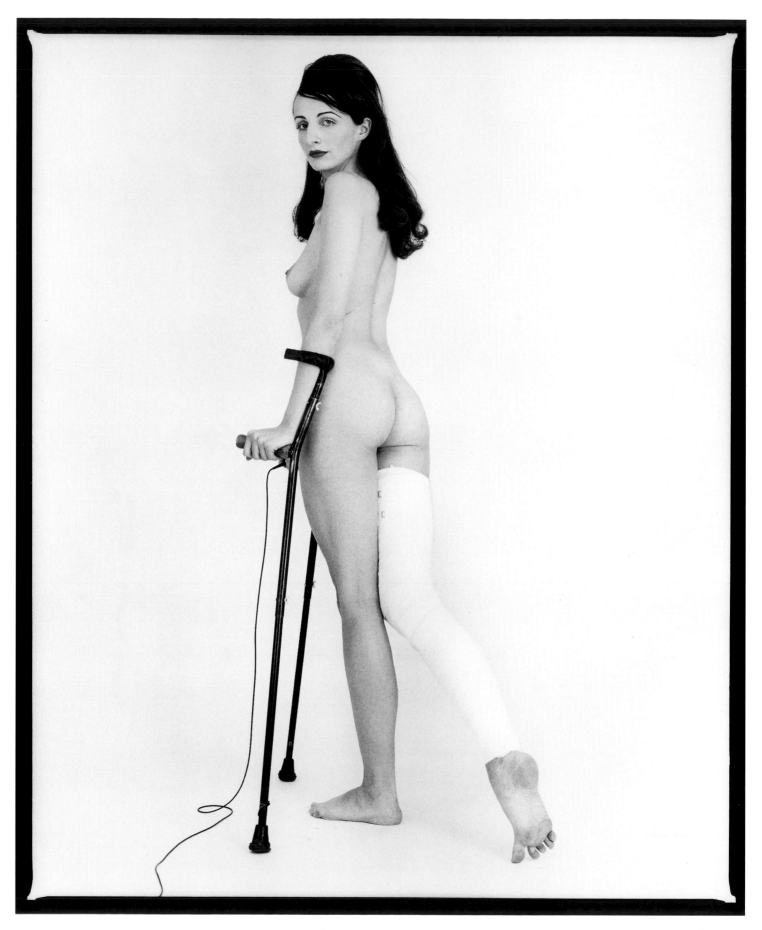

ALEXANDRA

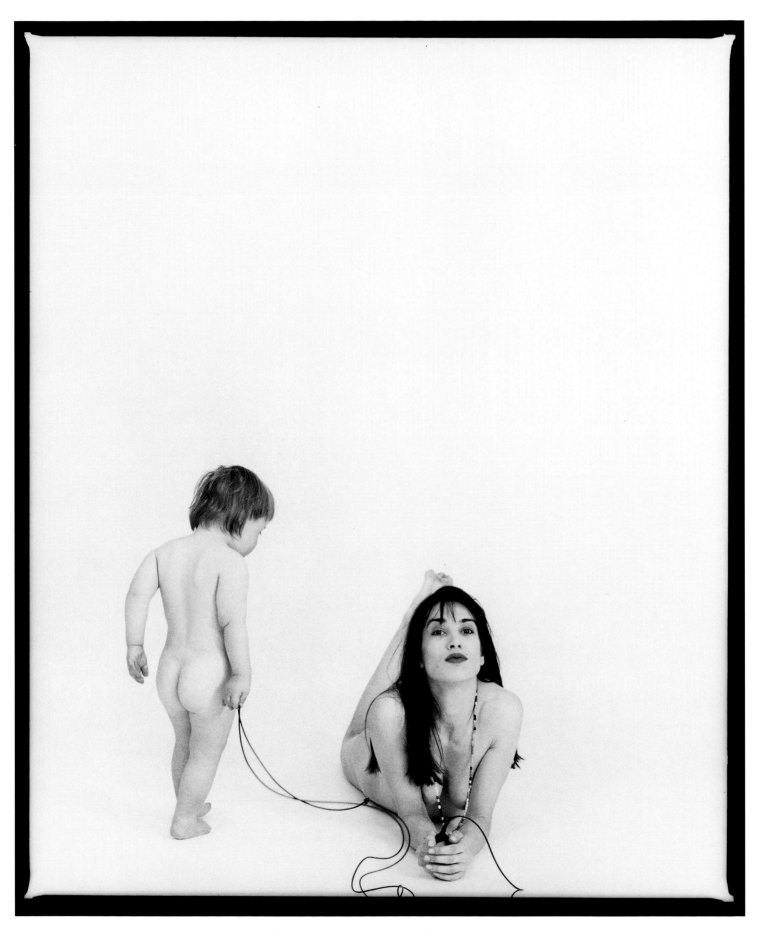

J A C Q U E L I N E , D A R B I

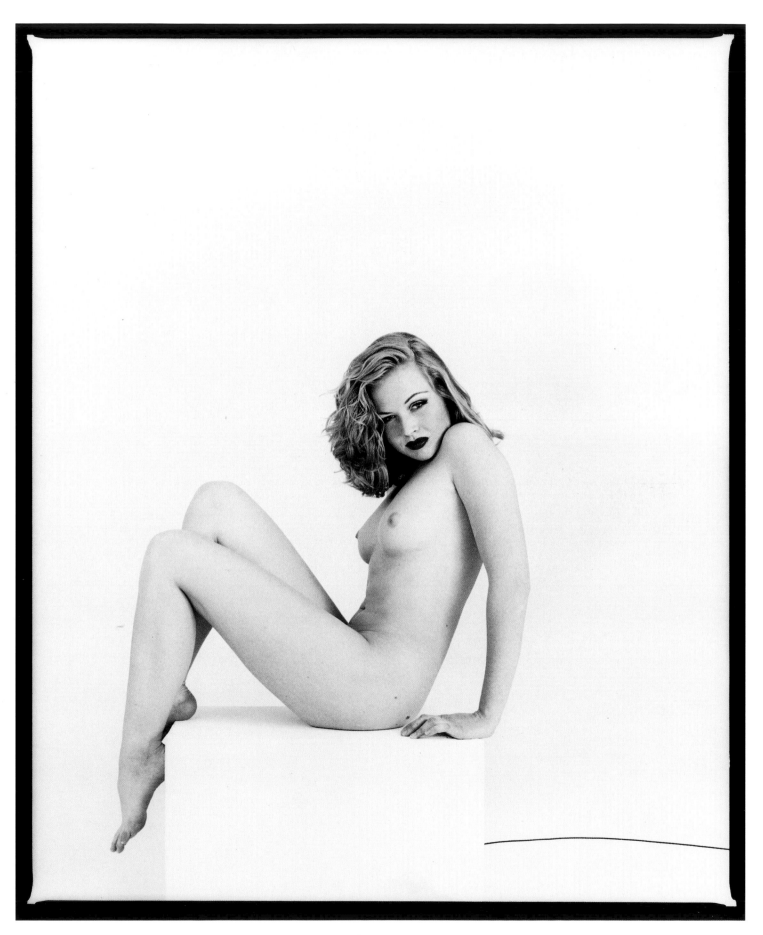

ANNA

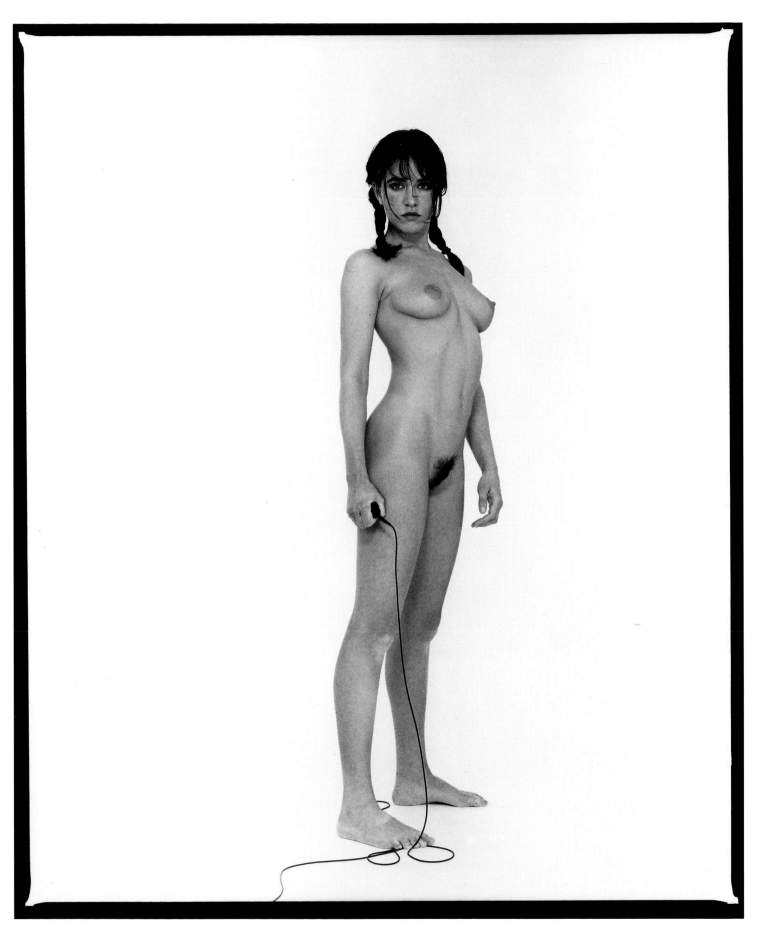

S A N D R A

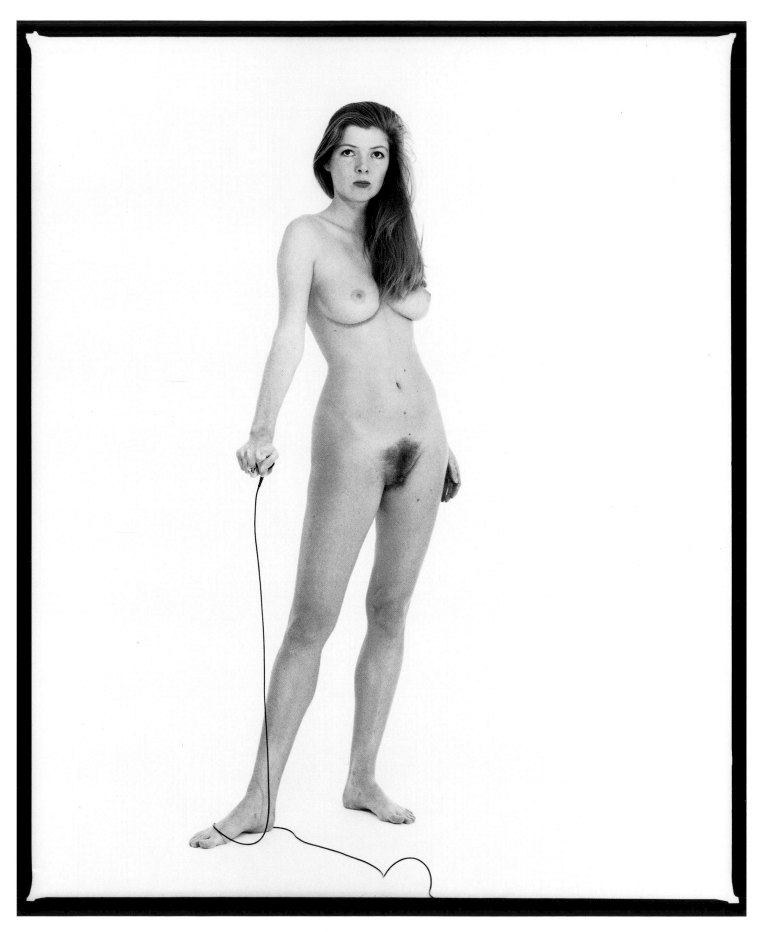

C H R I S T I N A

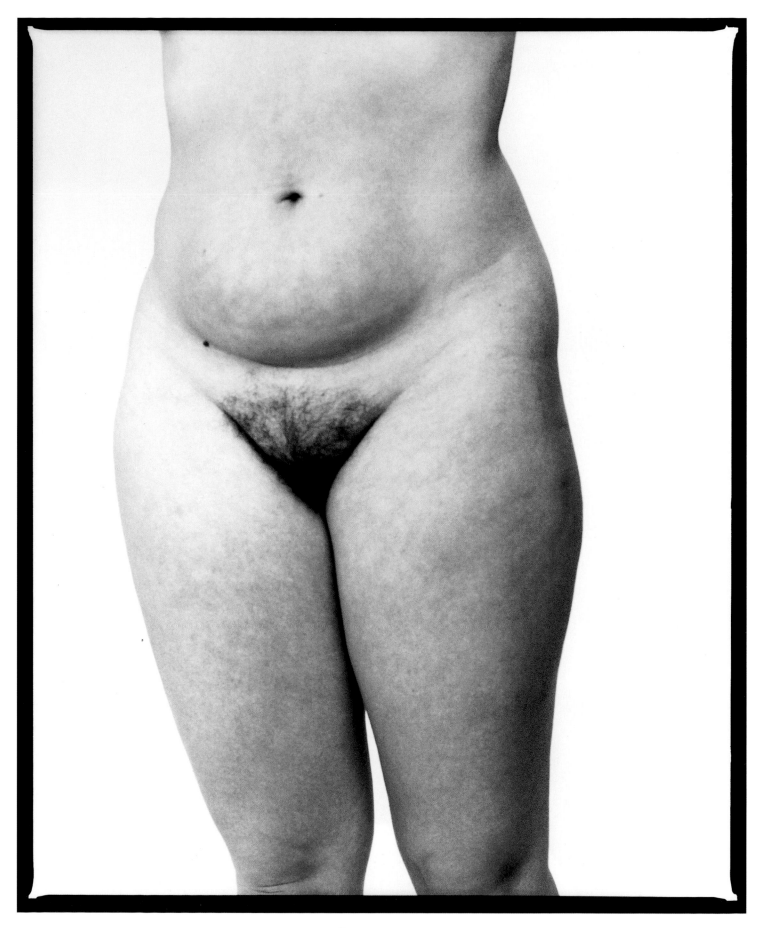

S A B R I N A

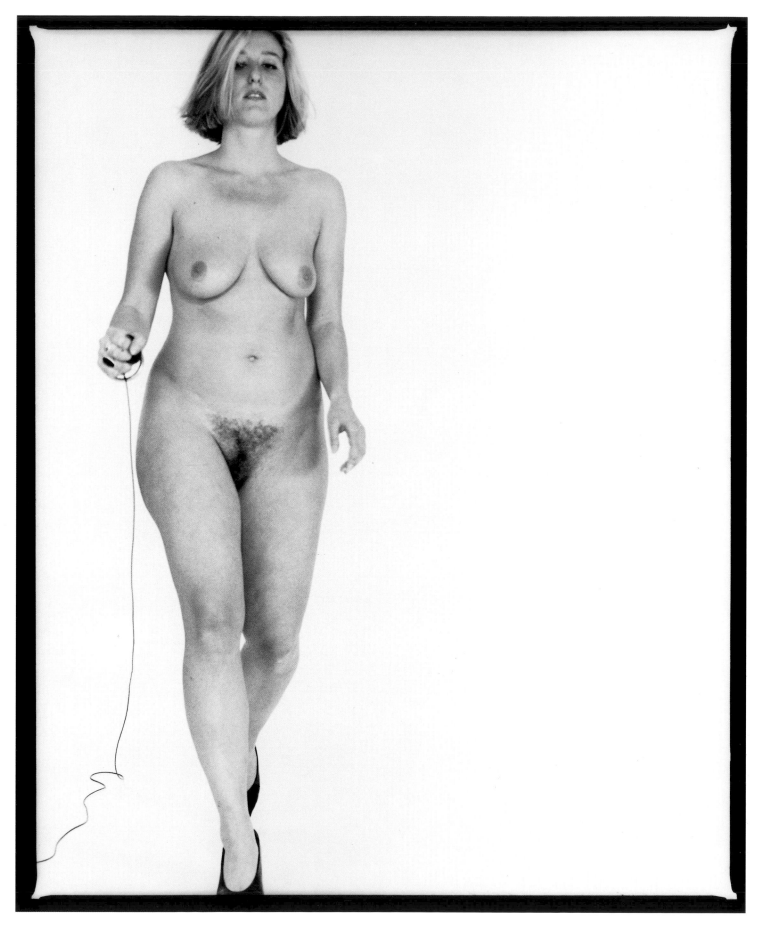

CRISSI

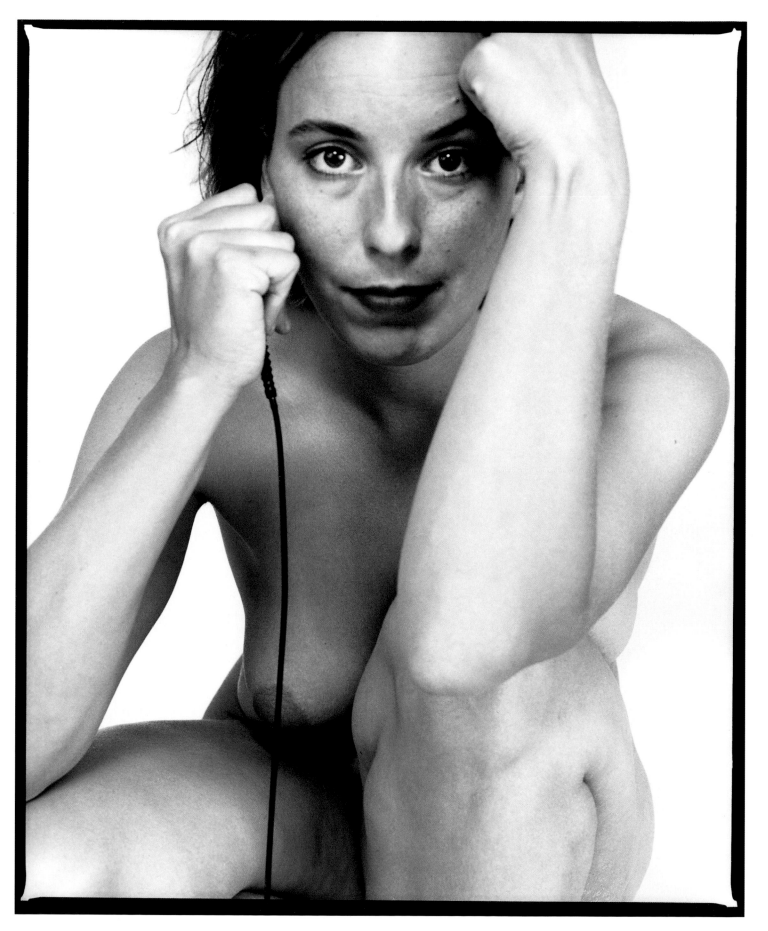

C H R I S T I N E

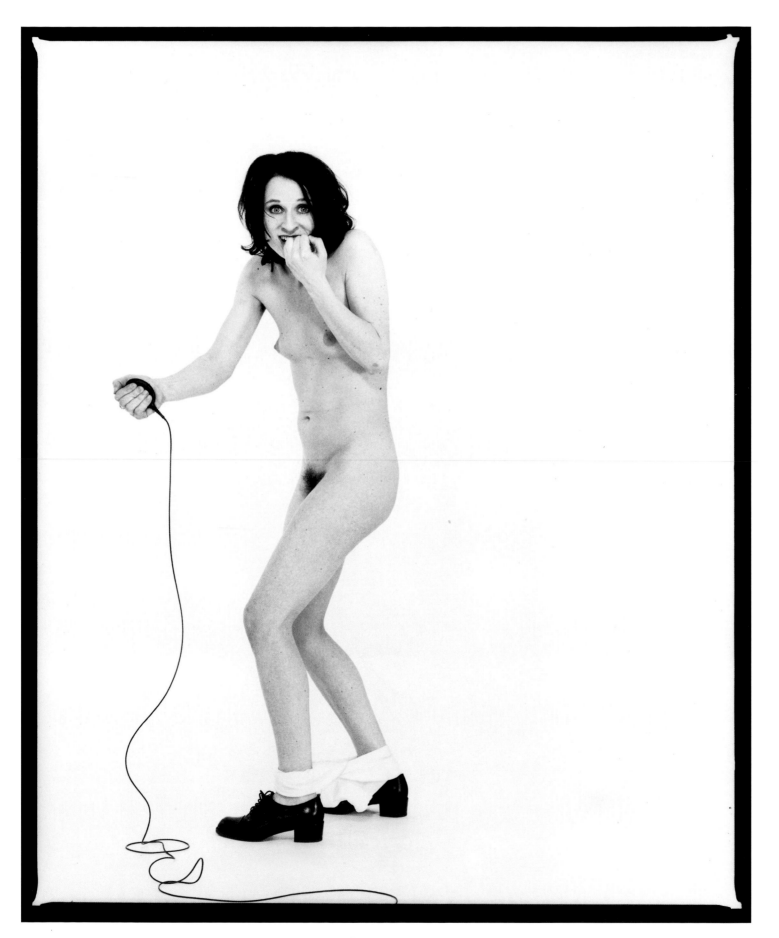

S O P H I E

43

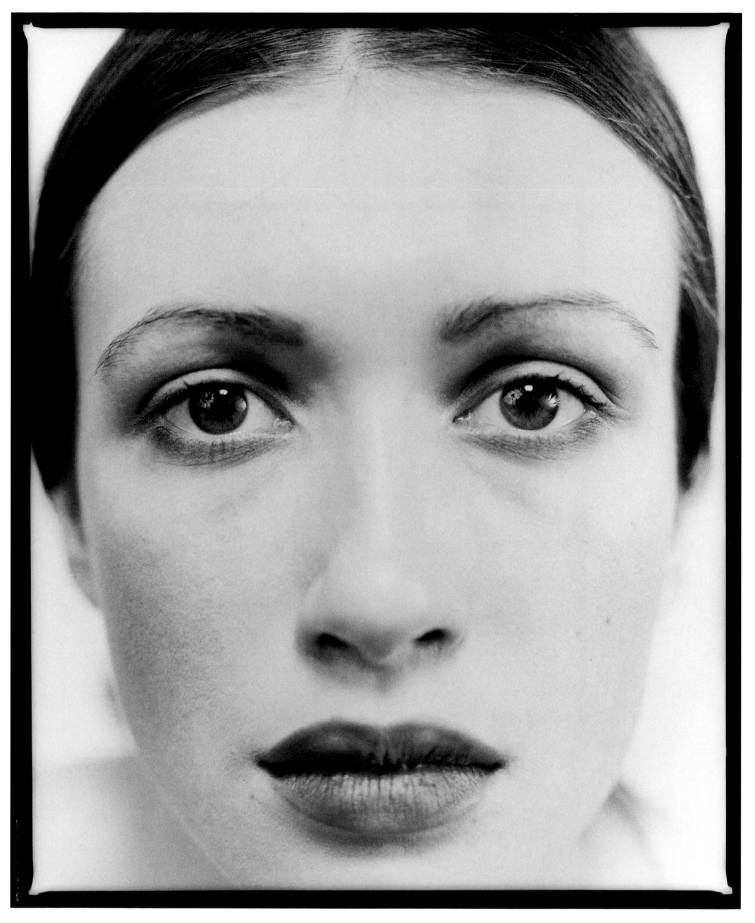

C L A U D I A

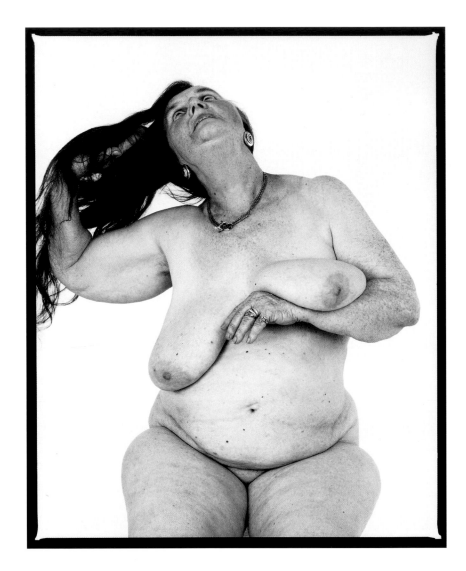

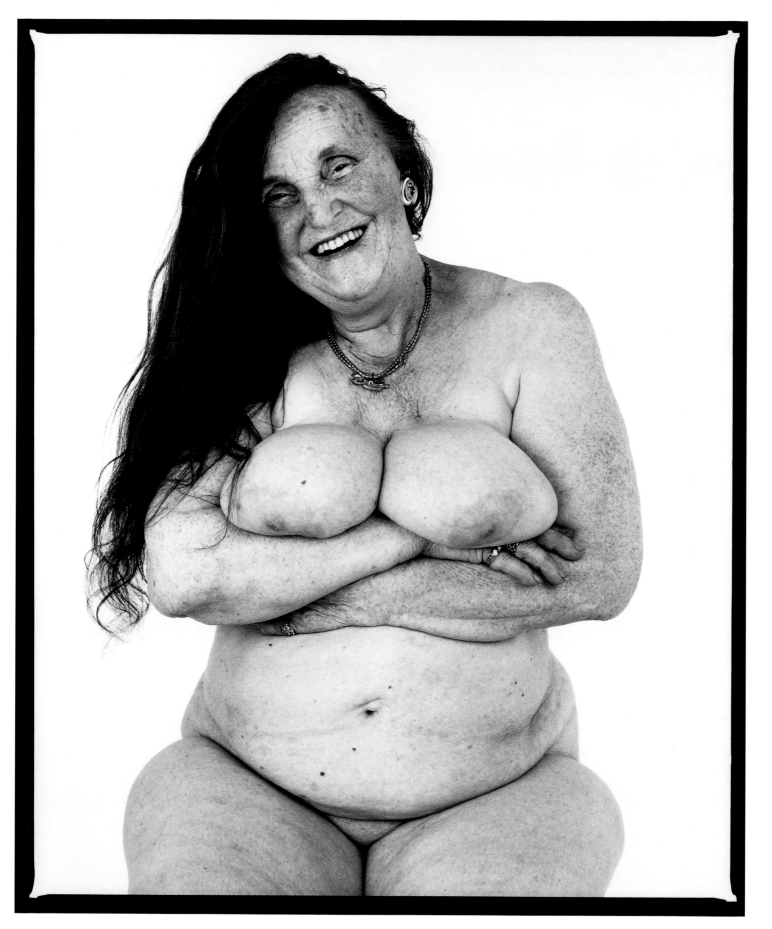

I N G E B O R G

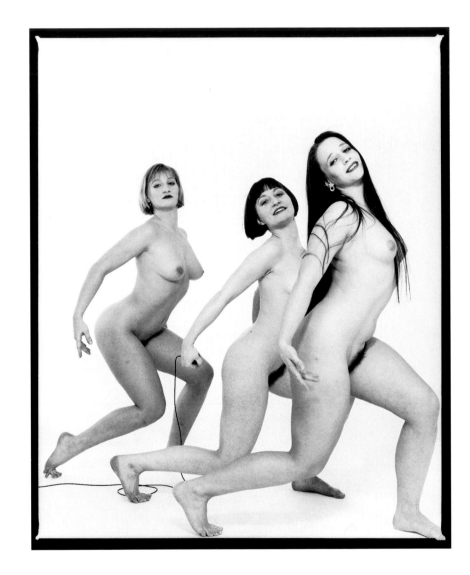

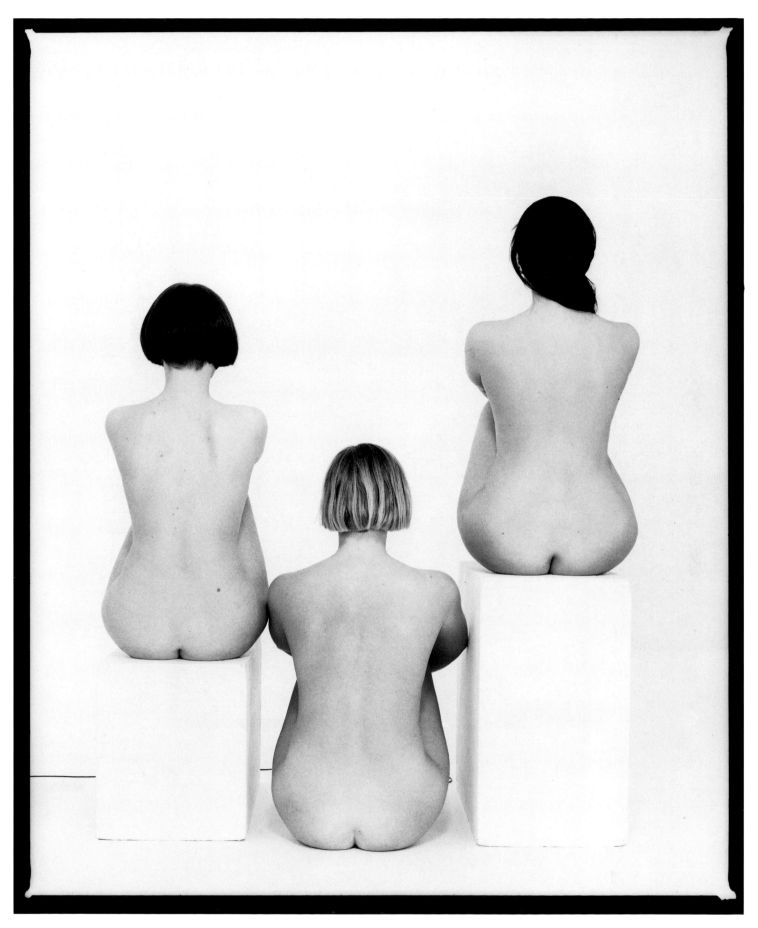

HARRIET, ITA, NORMA

49

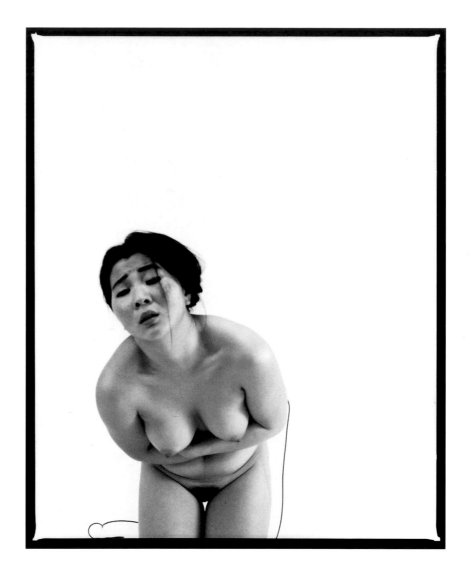

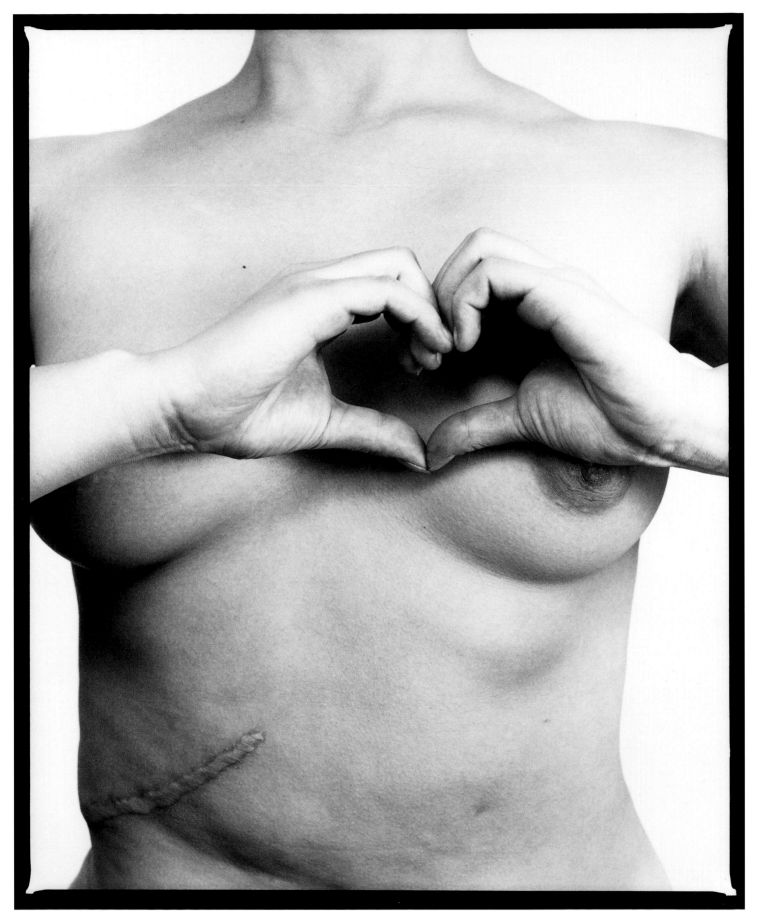

A E S I M

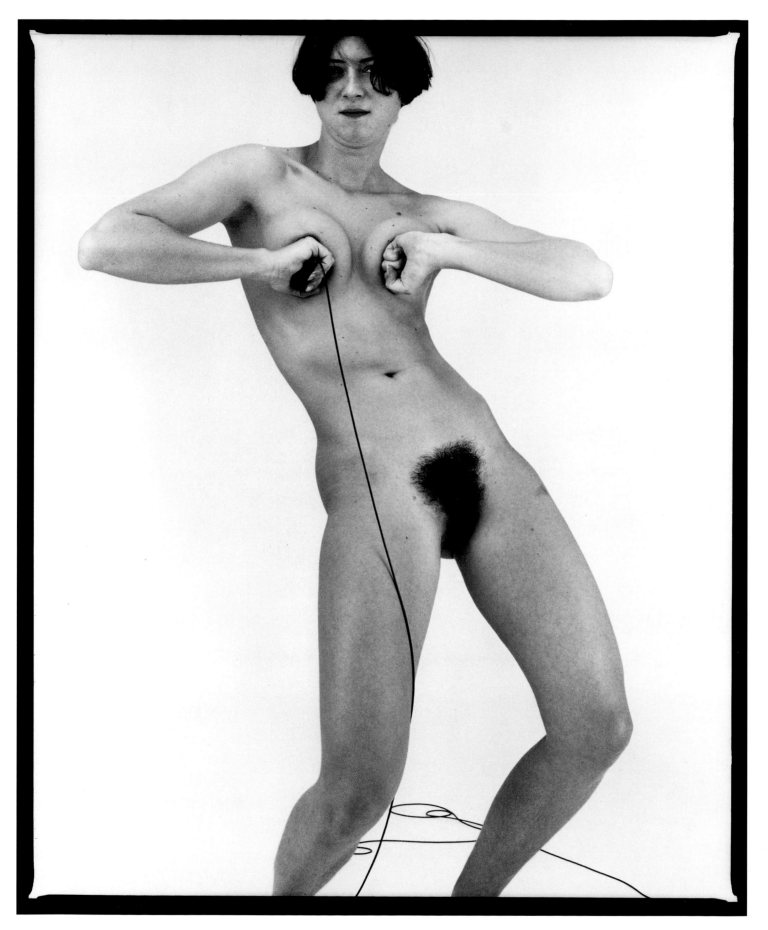

IVANA

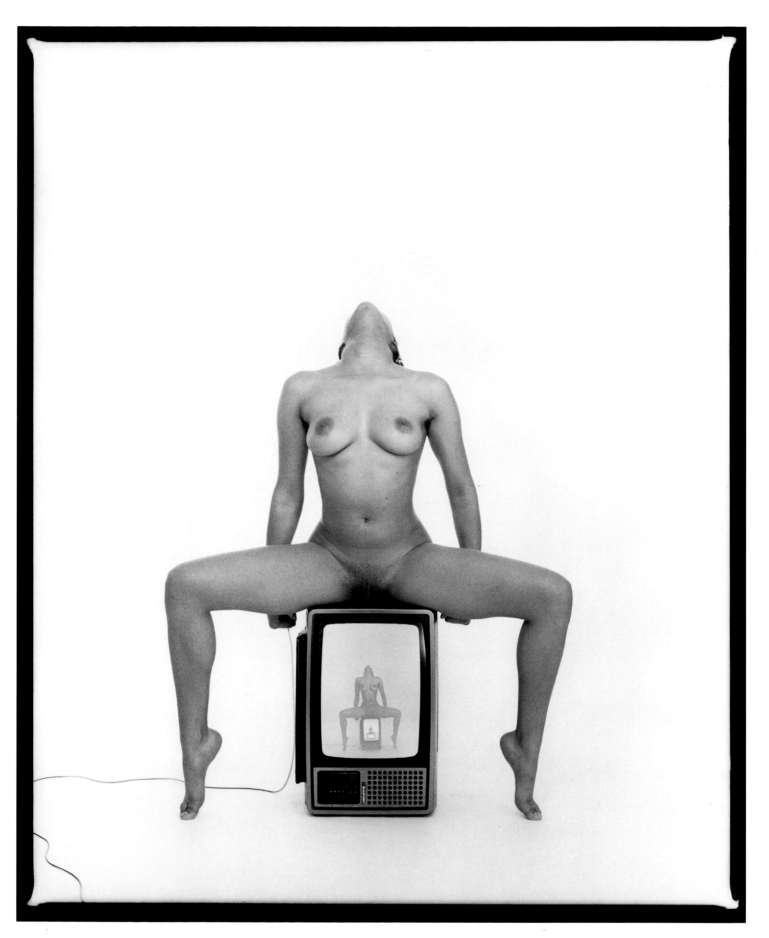

VALETA

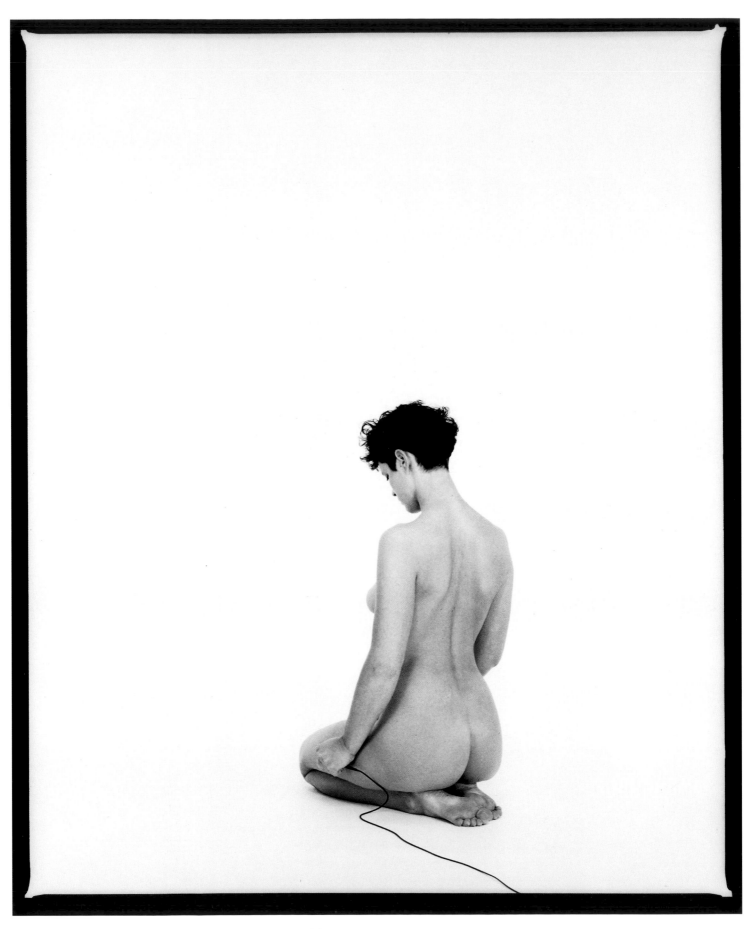

FRIEDERIKE

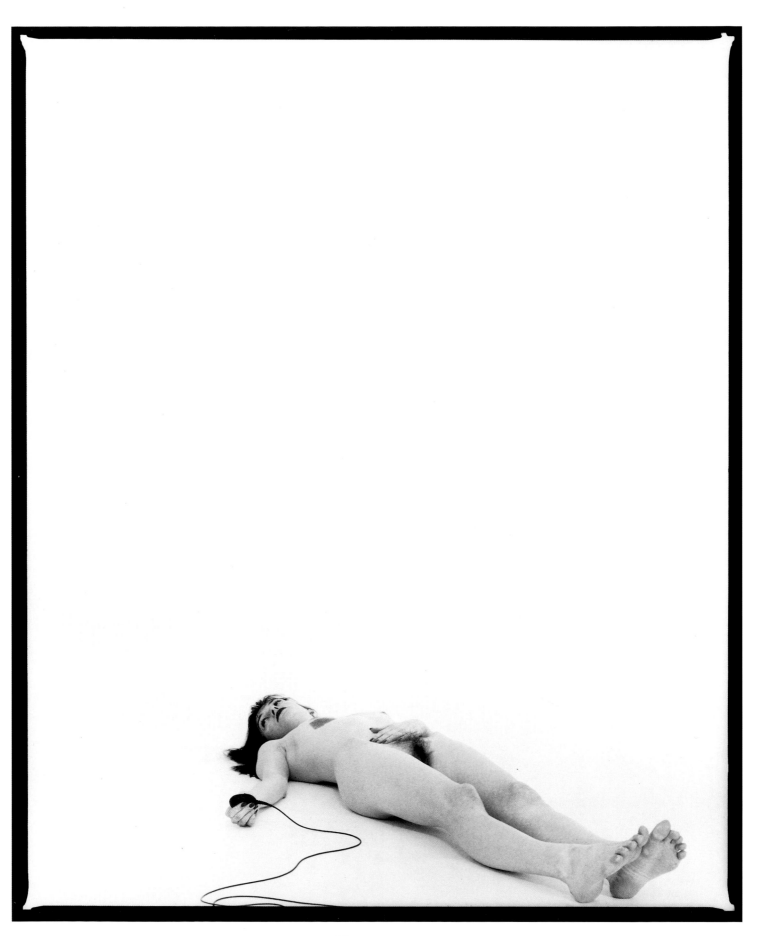

MONIKA

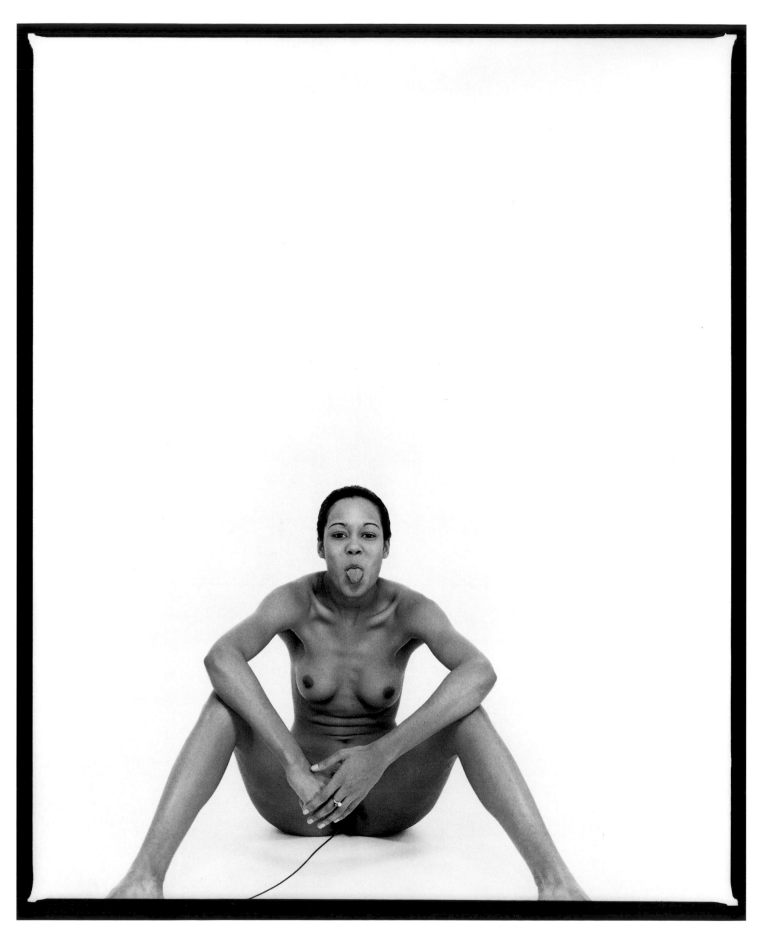

M Y R I A M

58

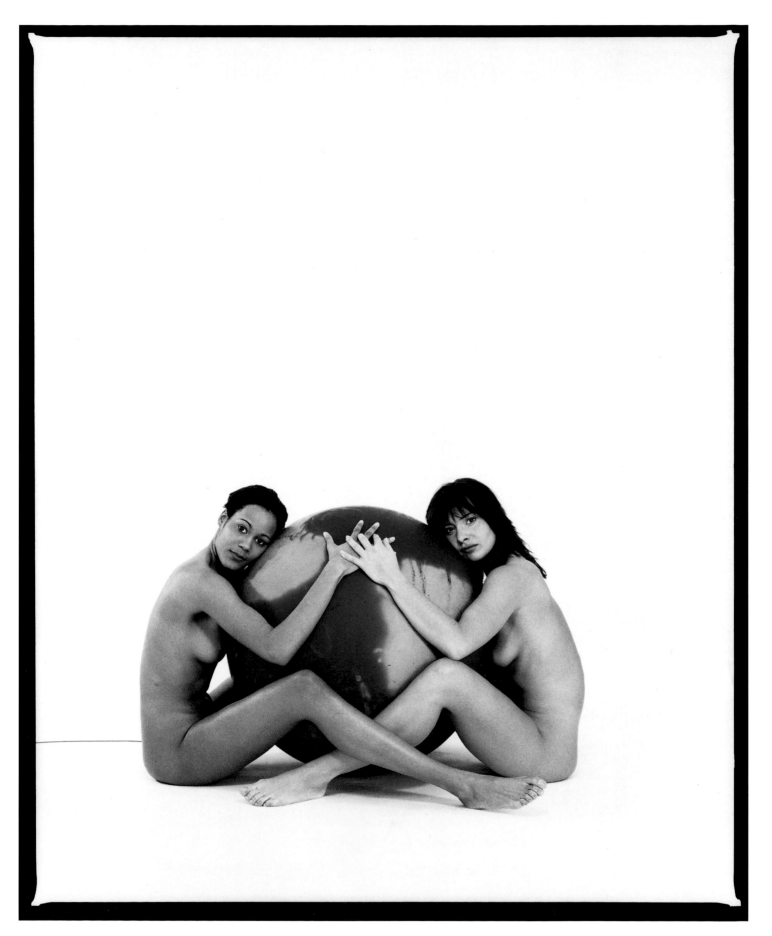

MYRIAM, ANNETT

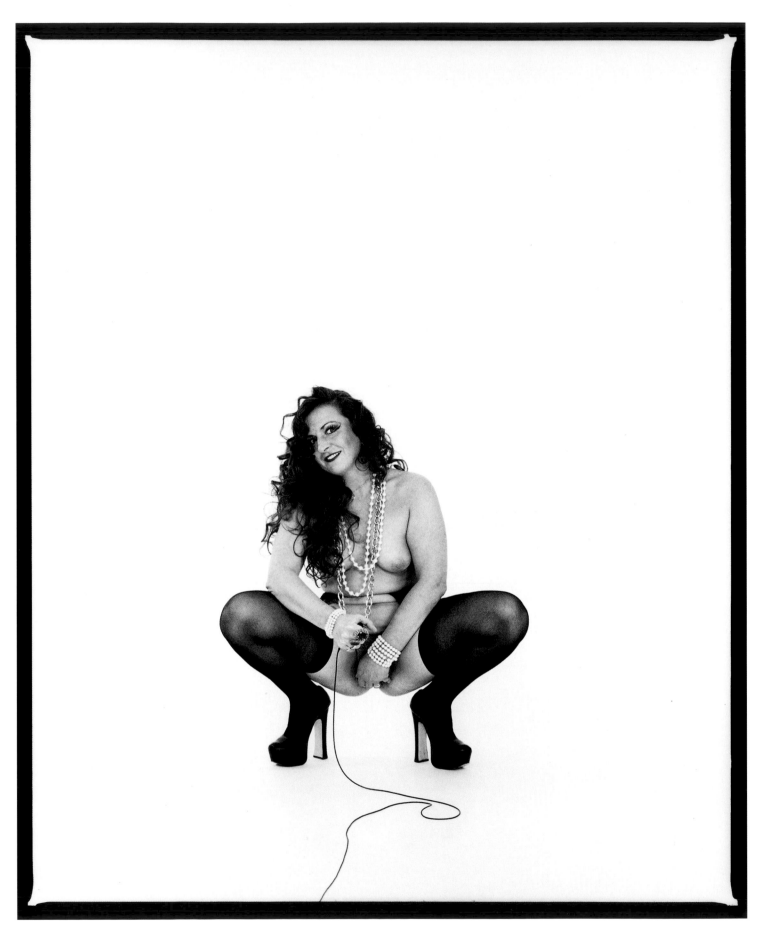

U T E

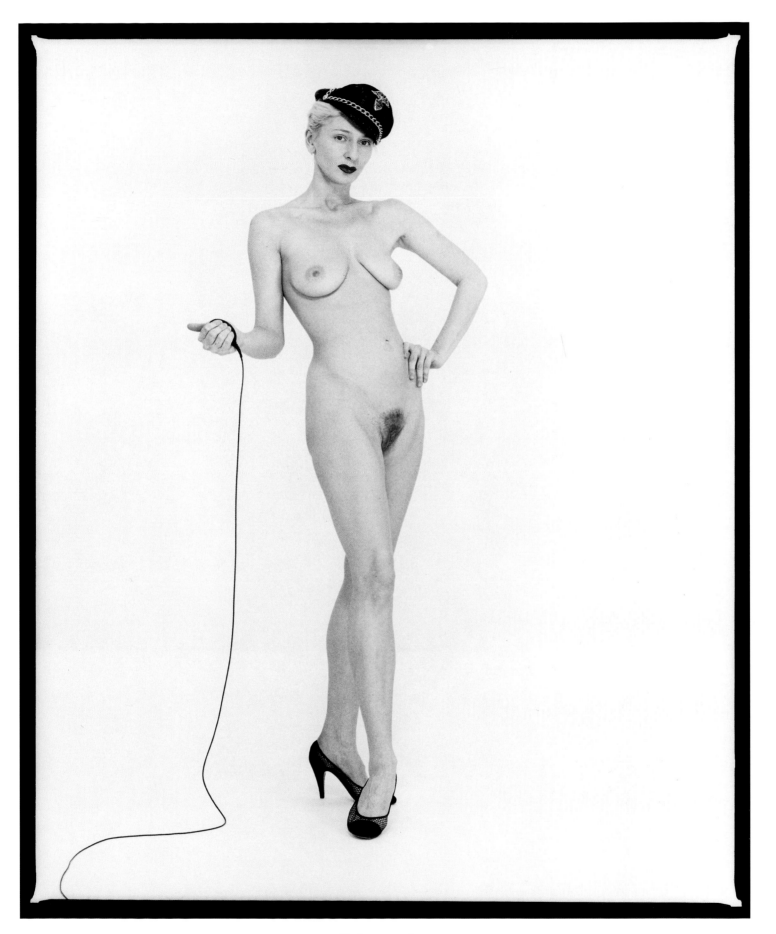

D É S I R É E

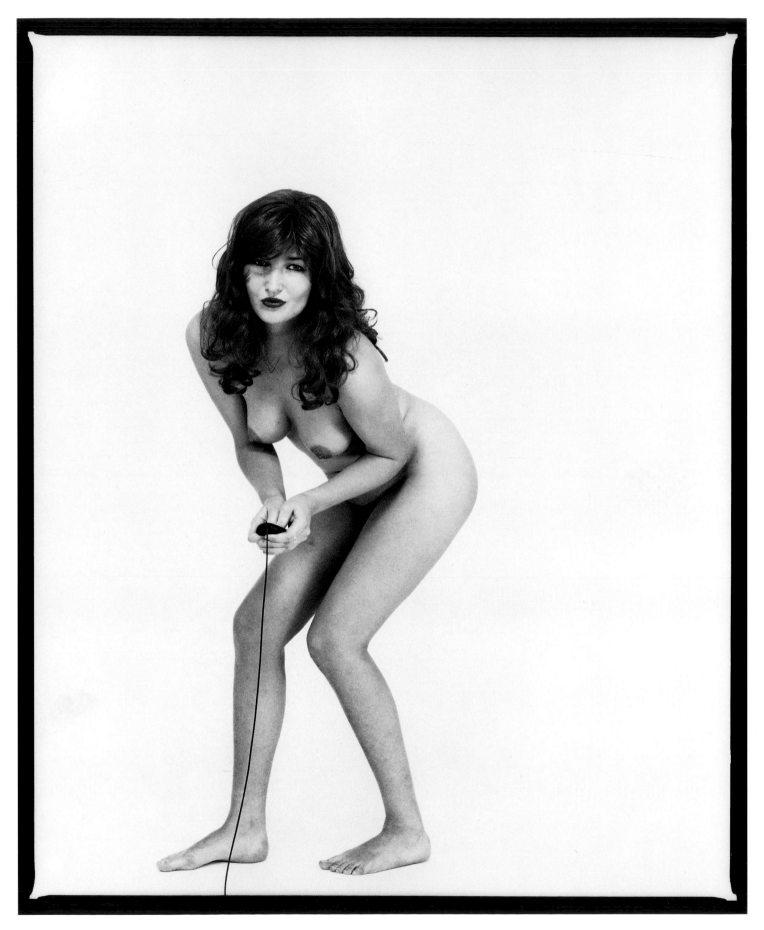

P E T R A

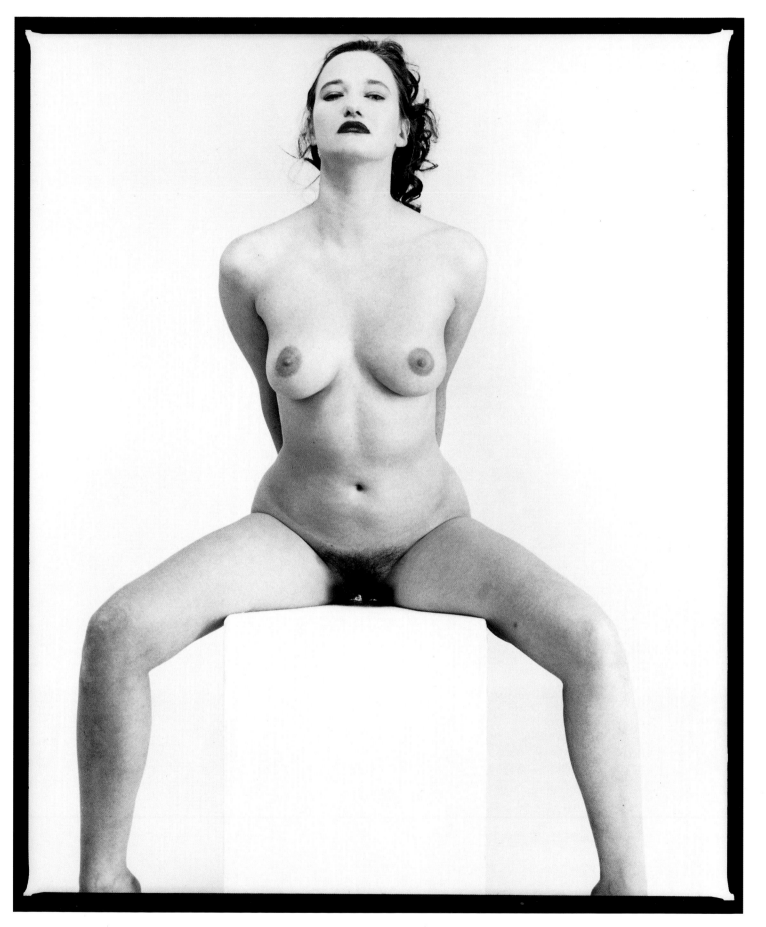

IRIS

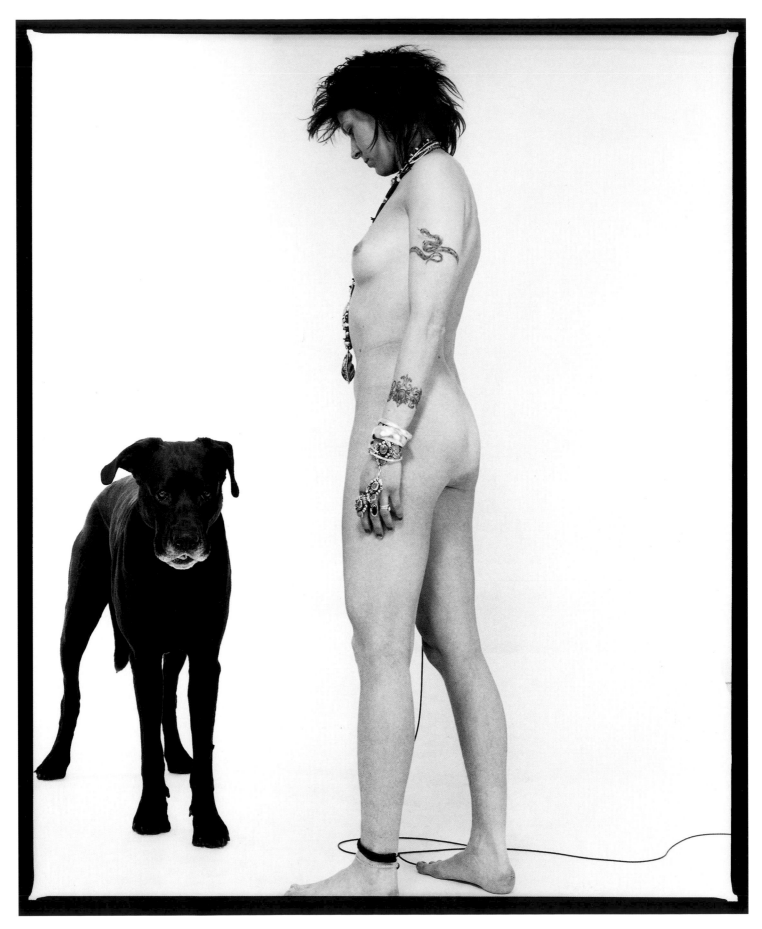

CRISS, DRAGO

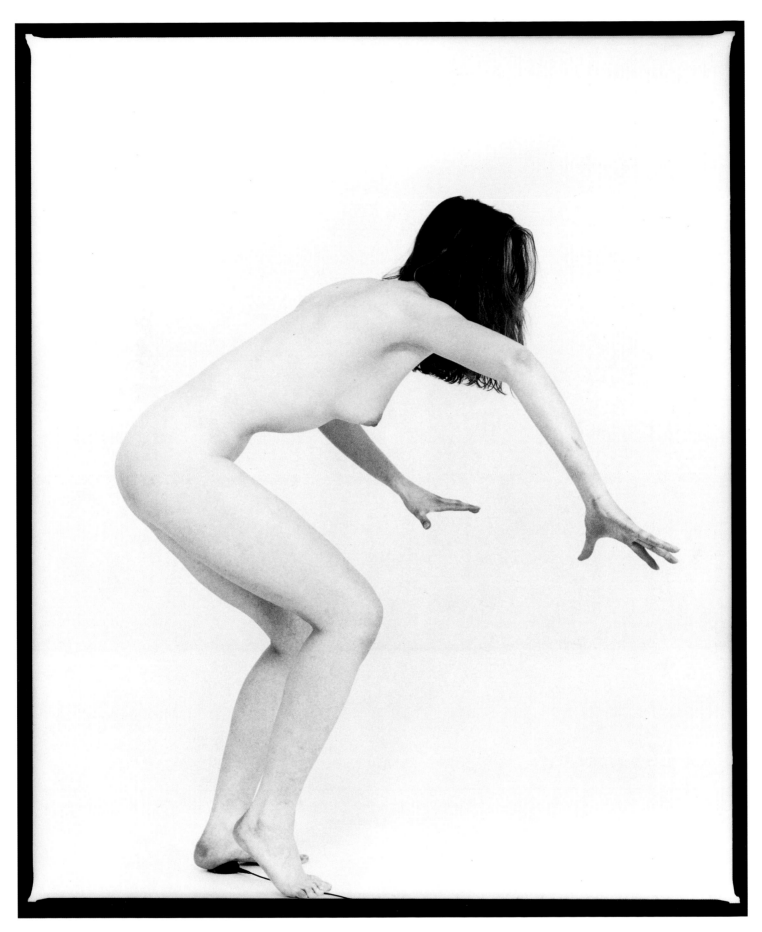

C O R I N N A

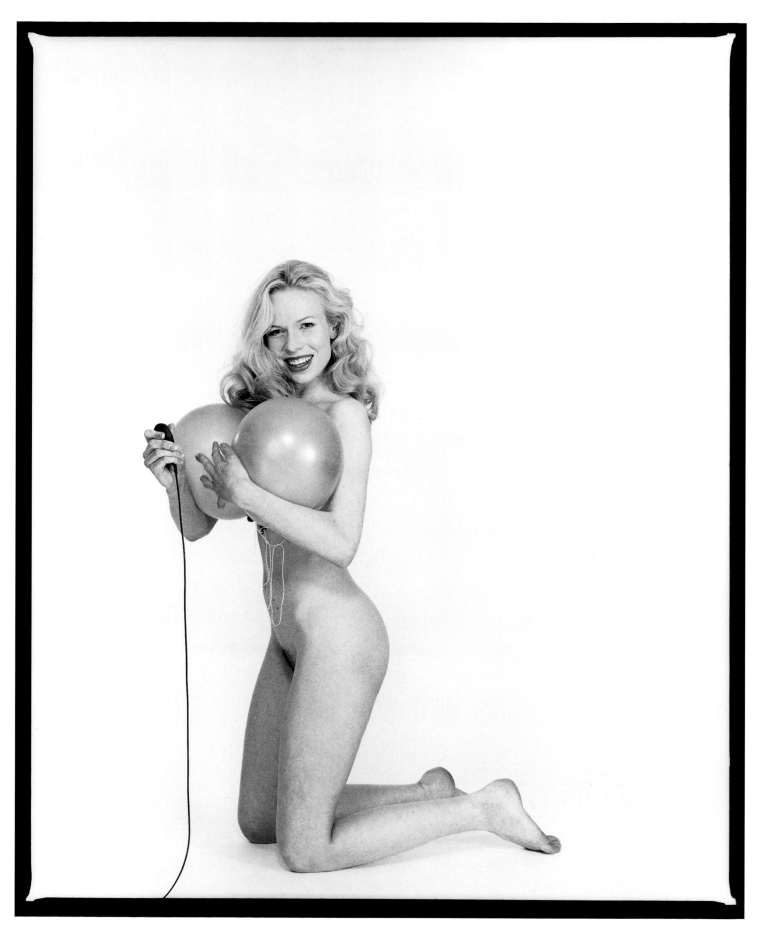

S A N D R A

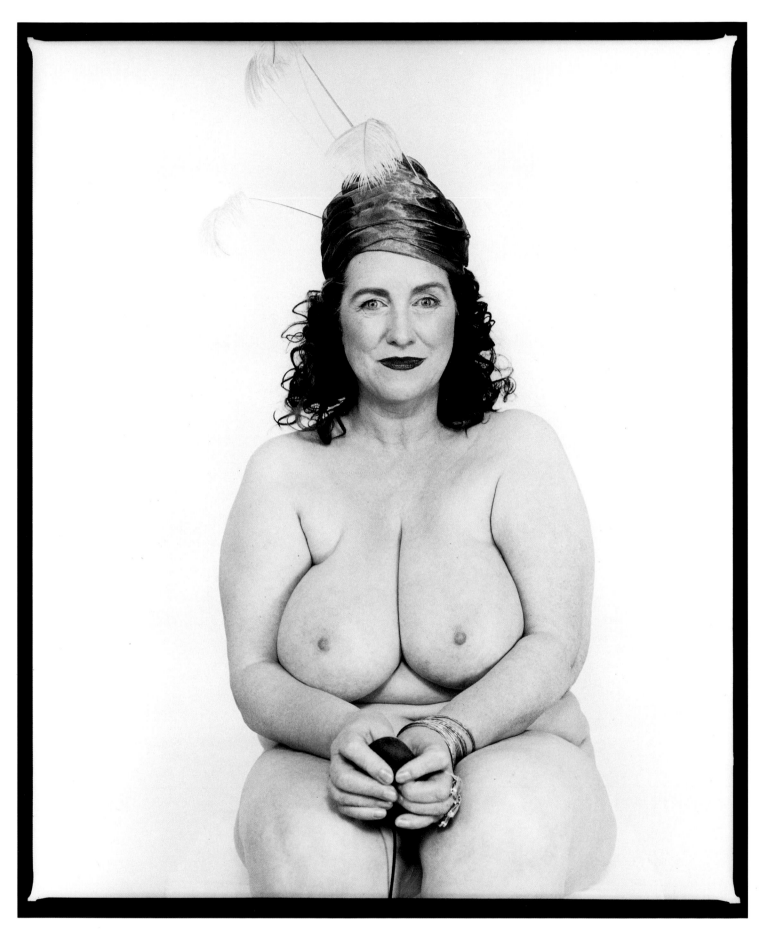

HELGA HELENA

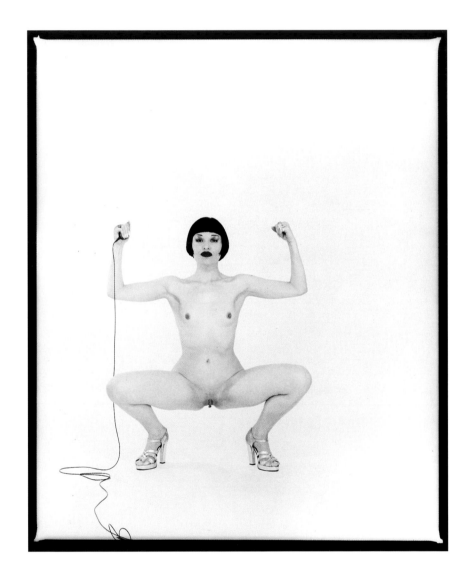

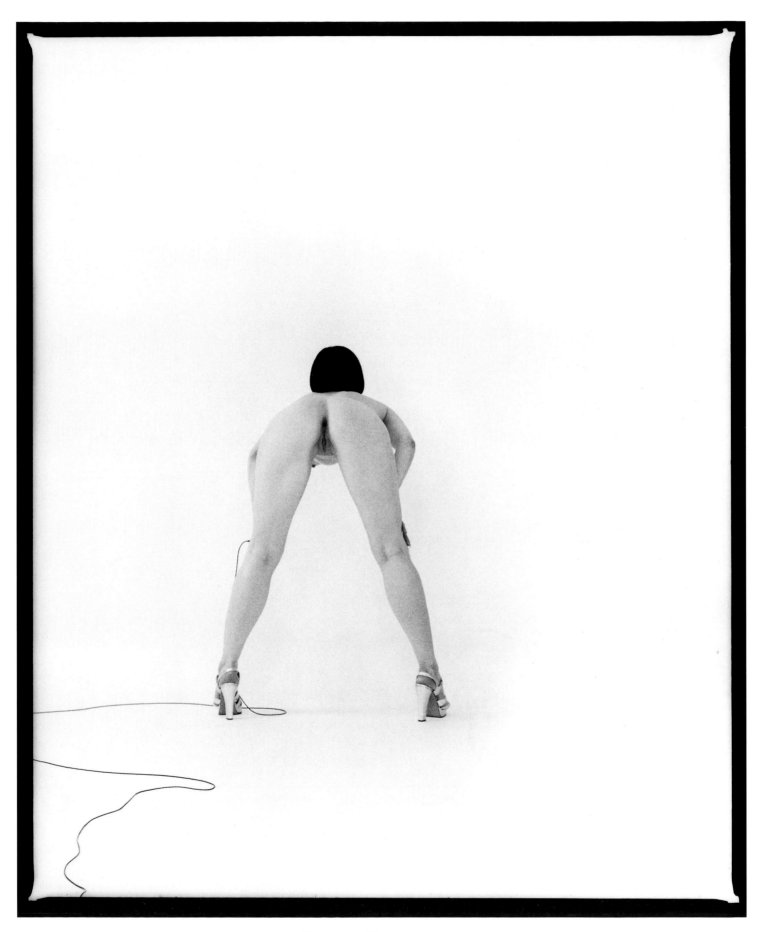

SABA KOMOSSA

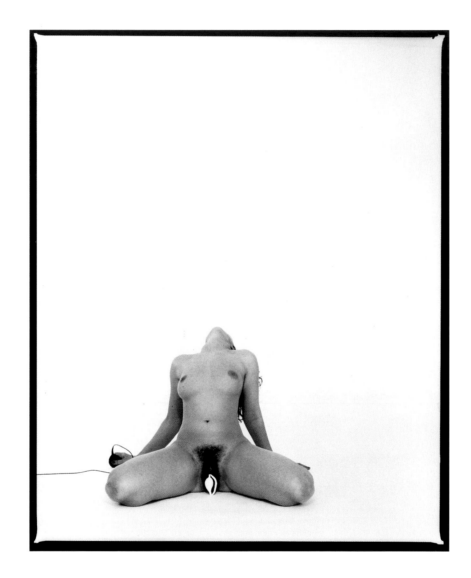

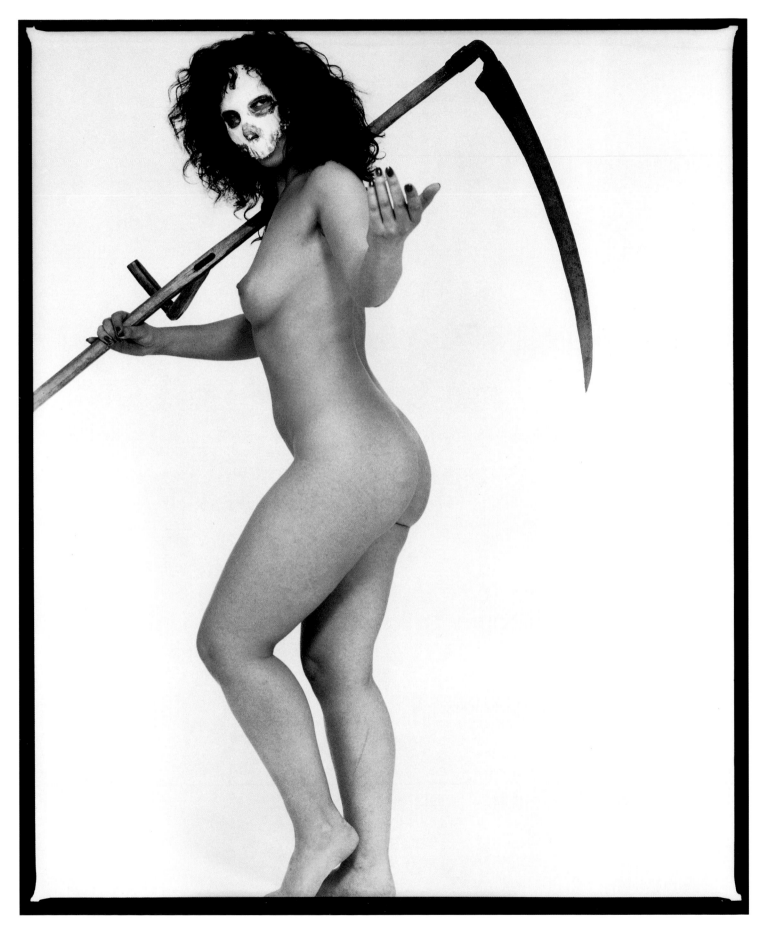

J .

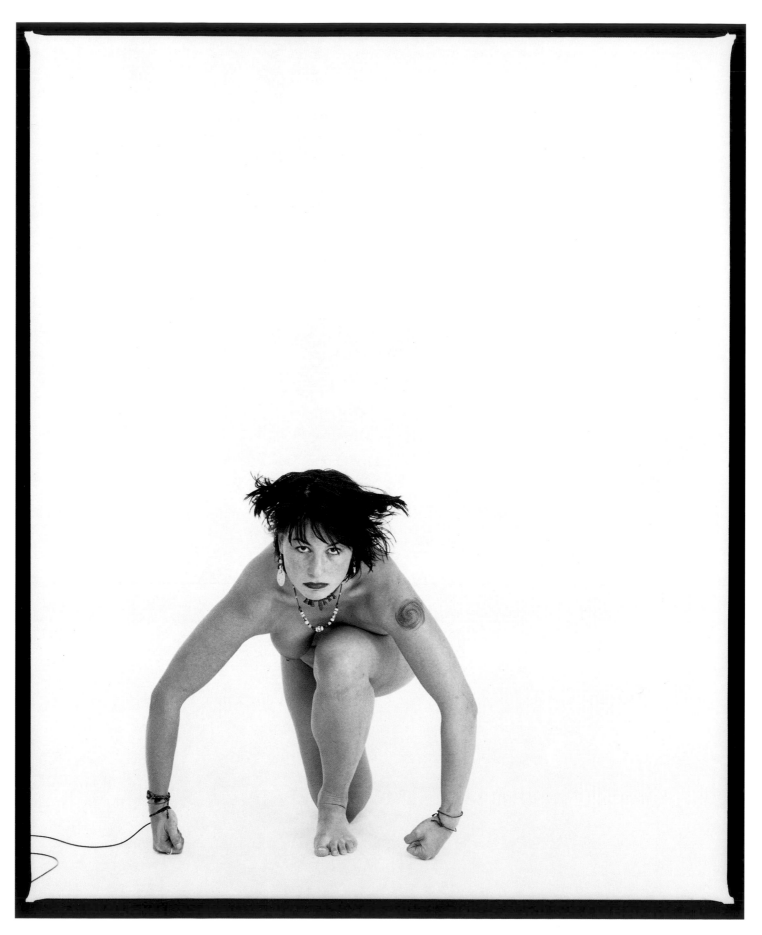

PANTERA

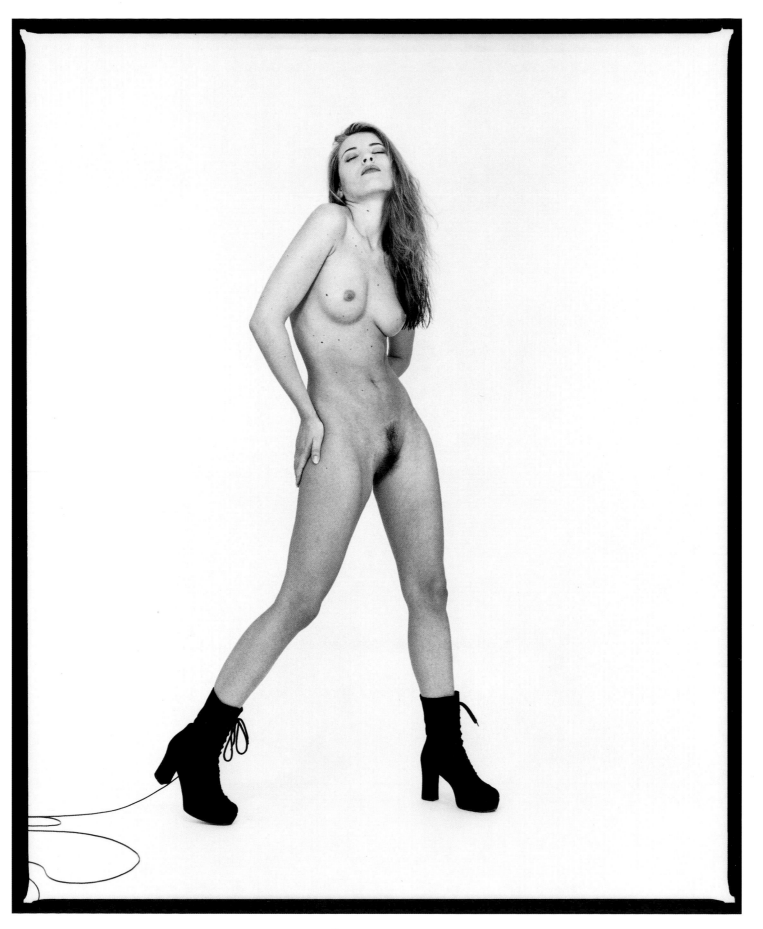

SUSANNE

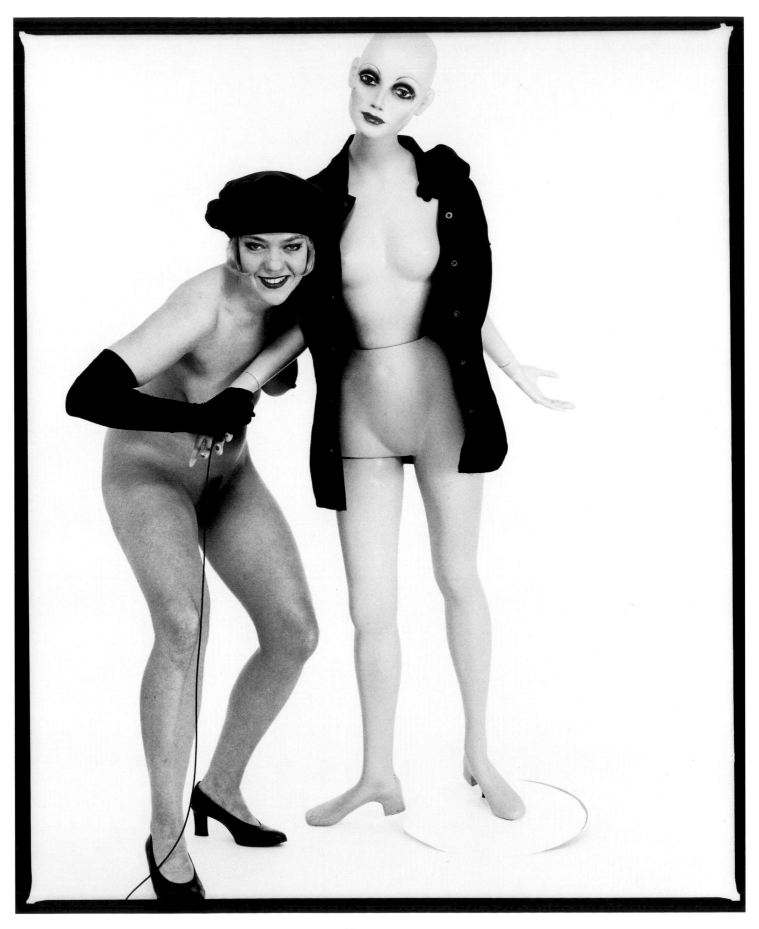

D I R K A

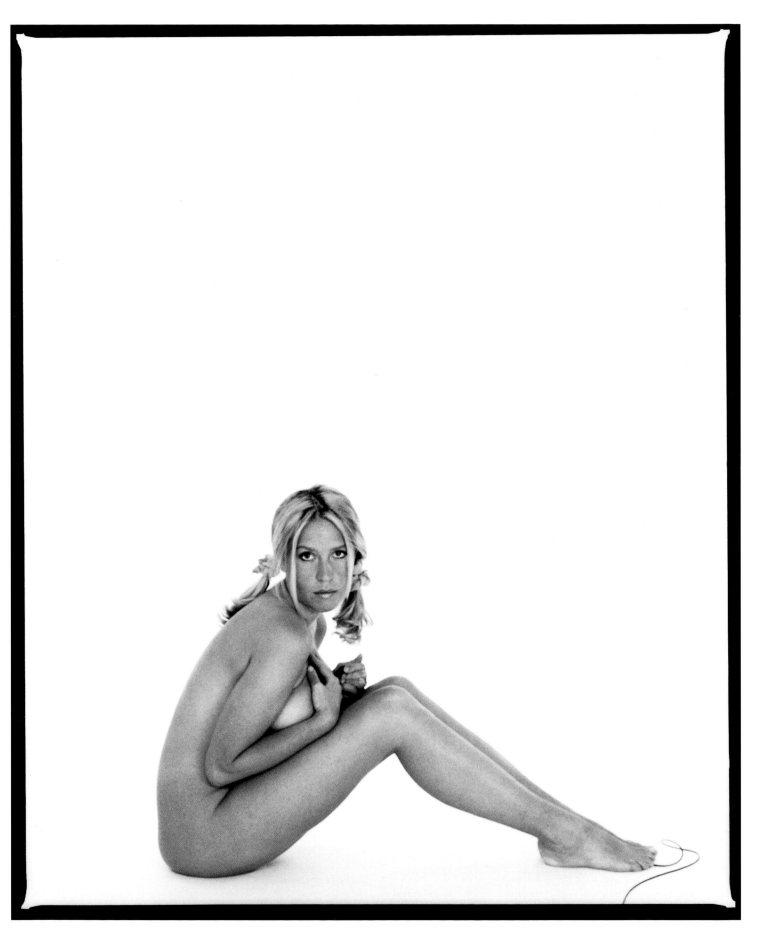

ANNA MARIA

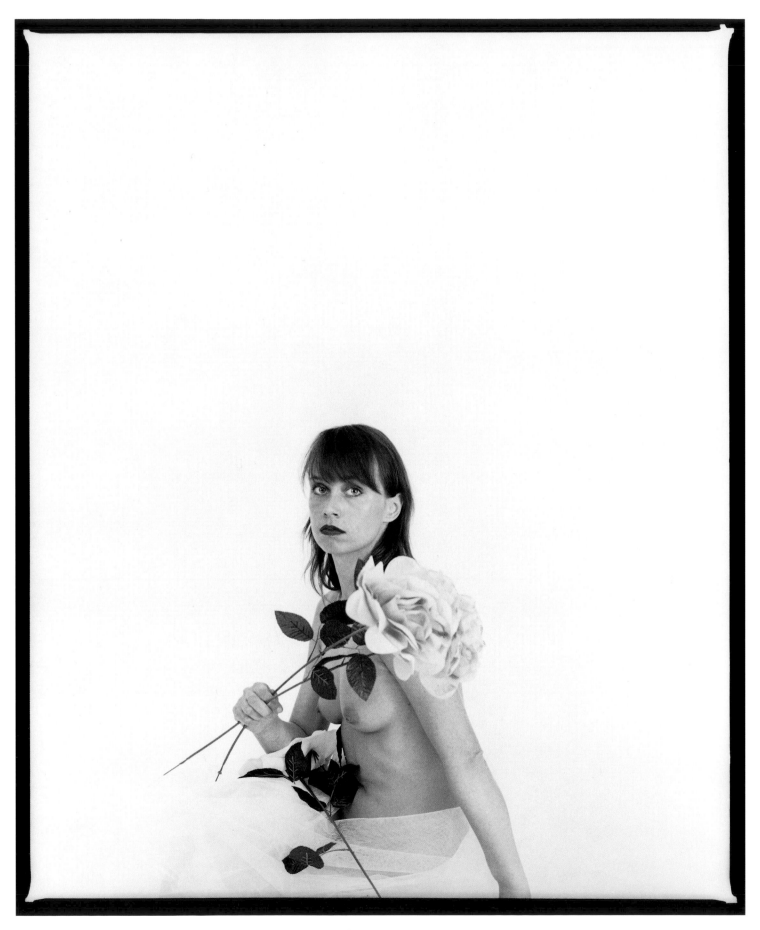

MIRIAM

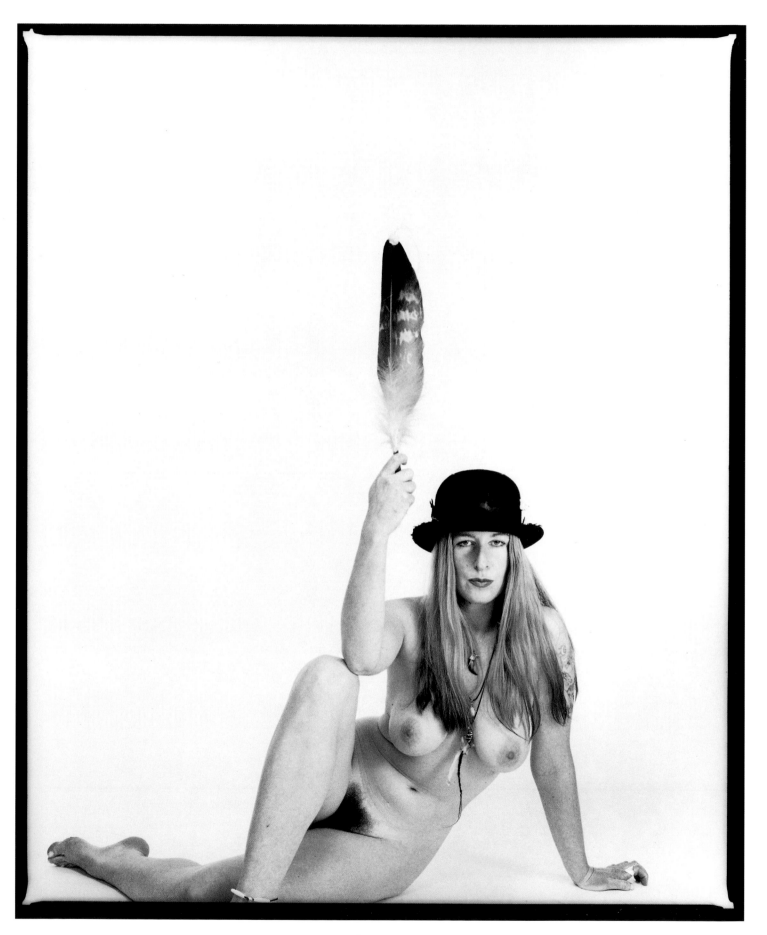

A N N A

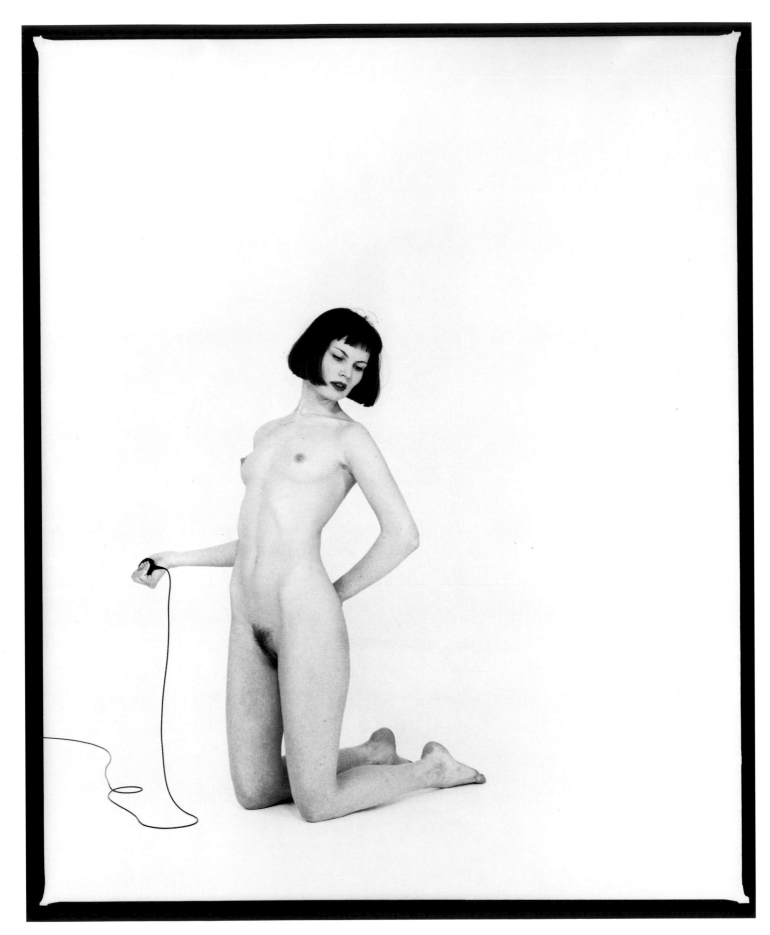

N O R A

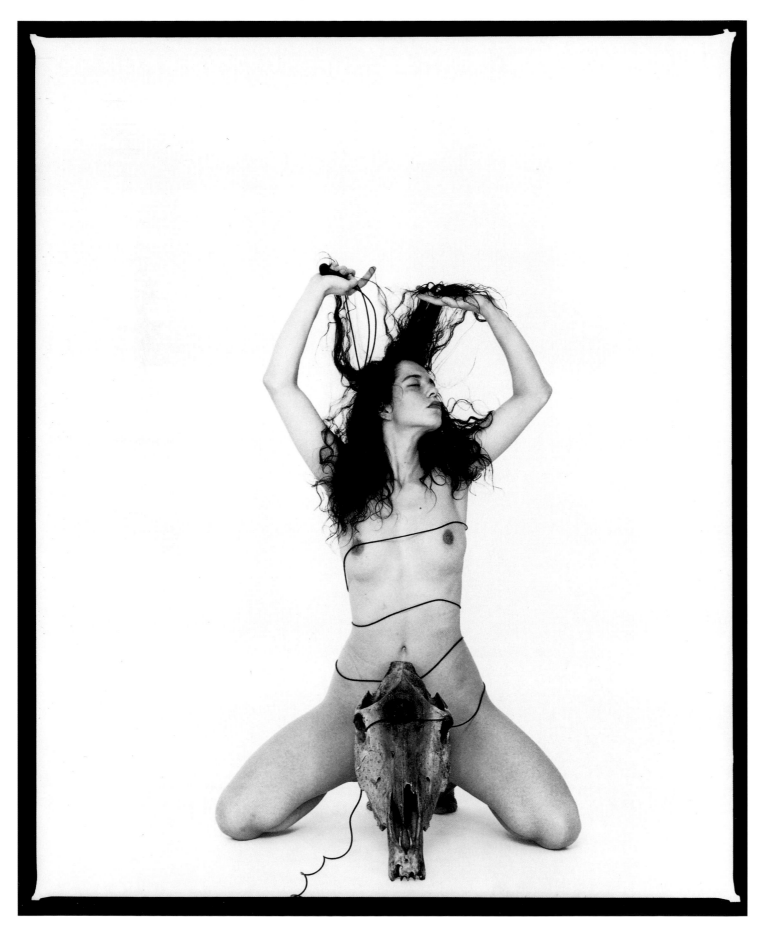

J A L E

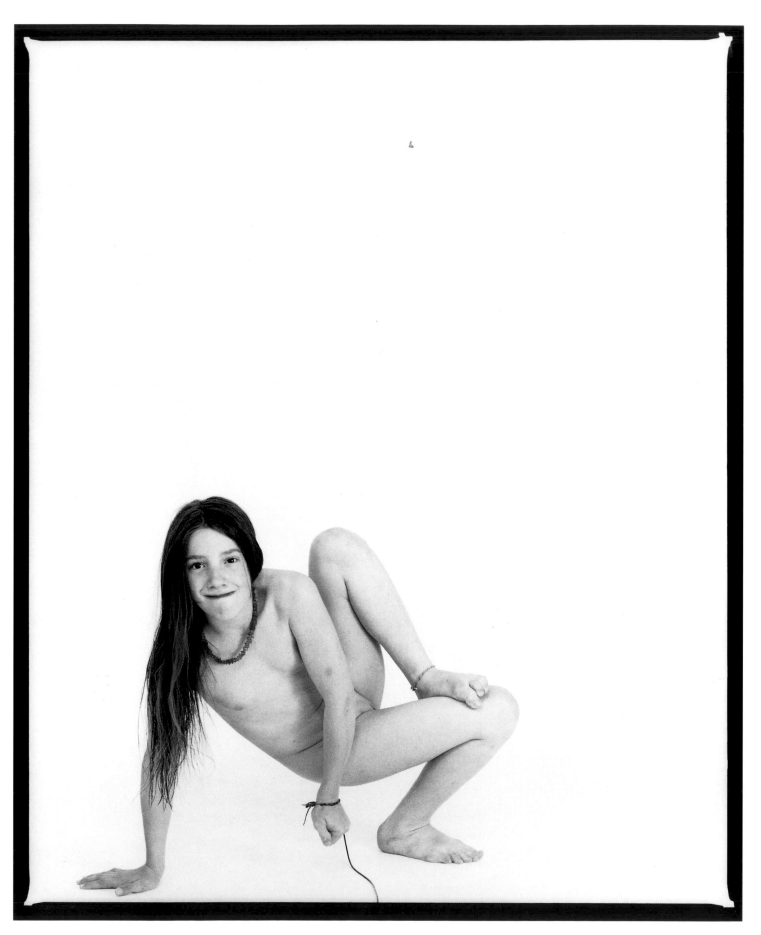

S O P H I E

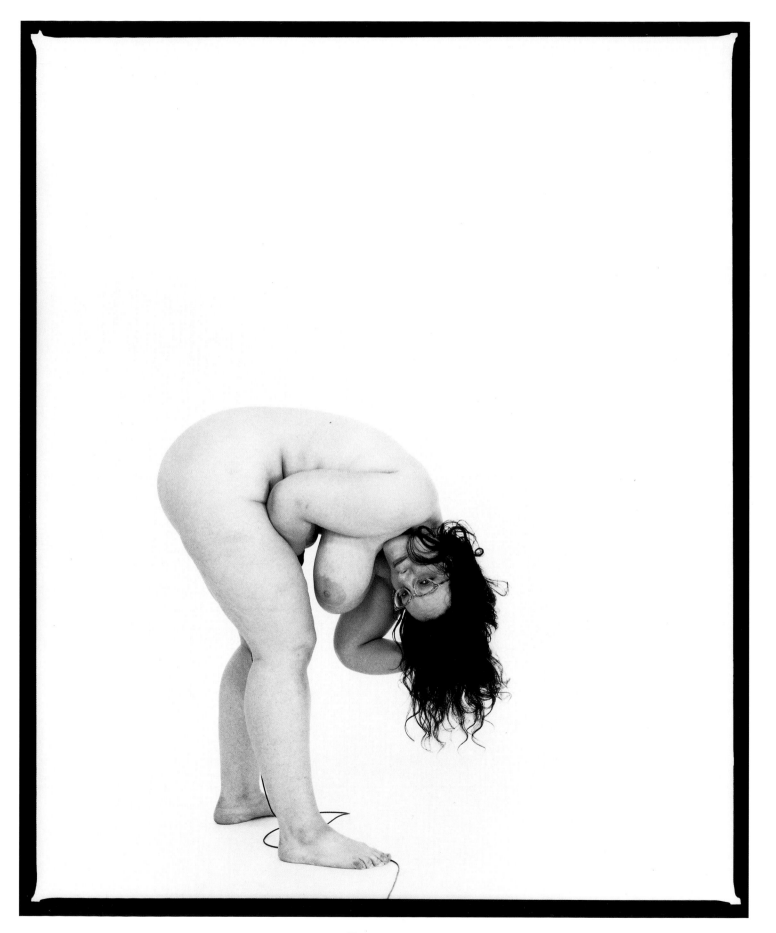

ULRIKE

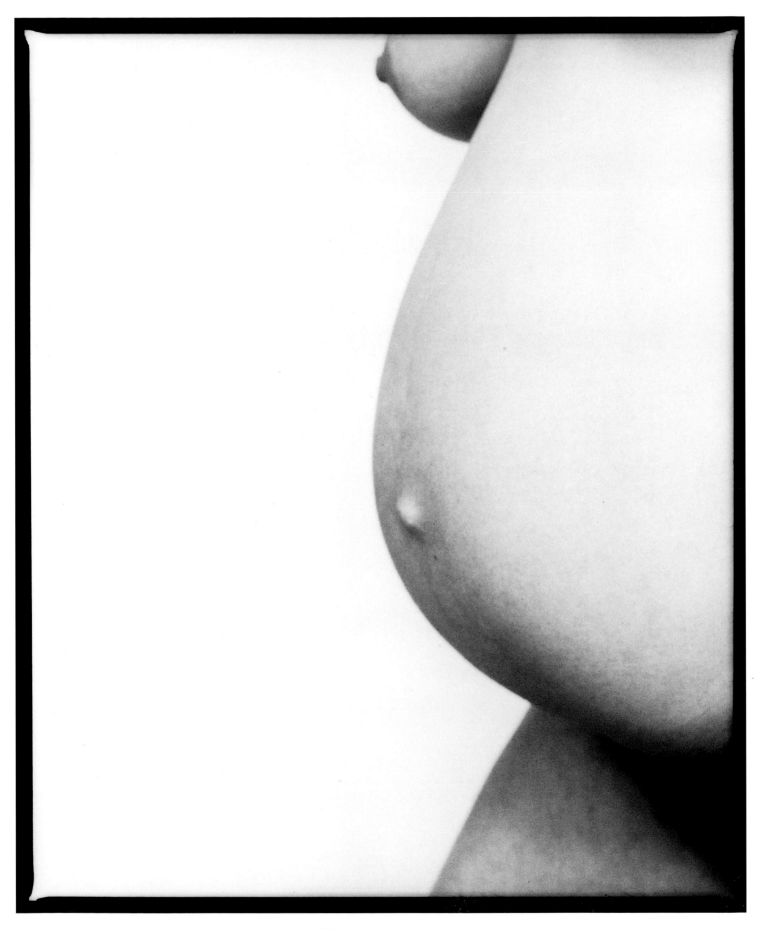

KATHARINA

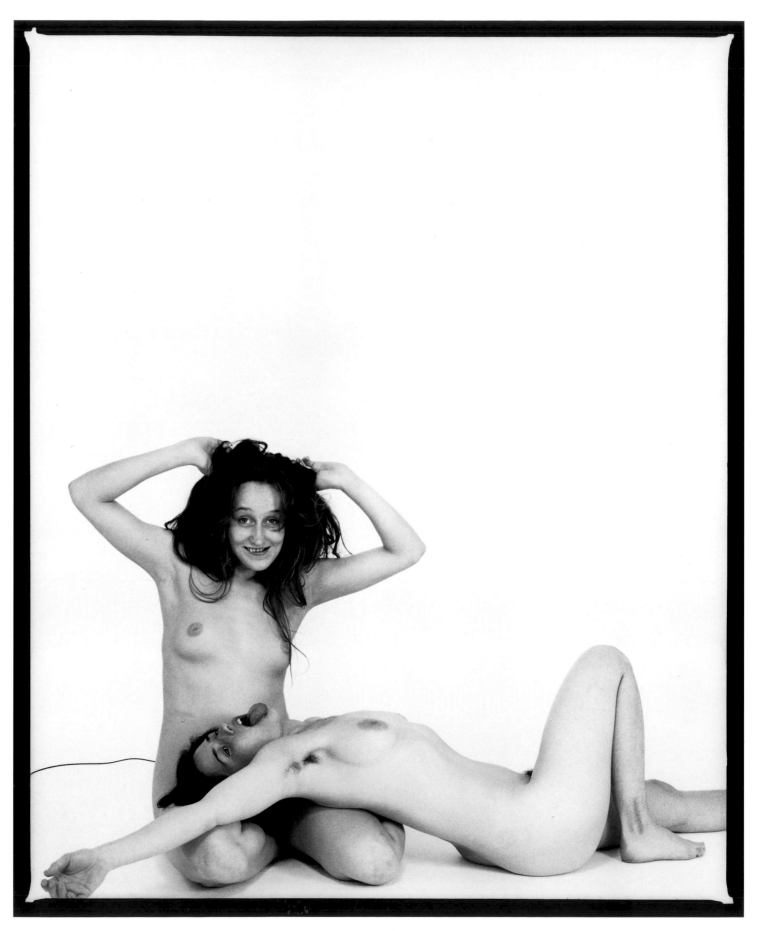

A N J A , I N E S

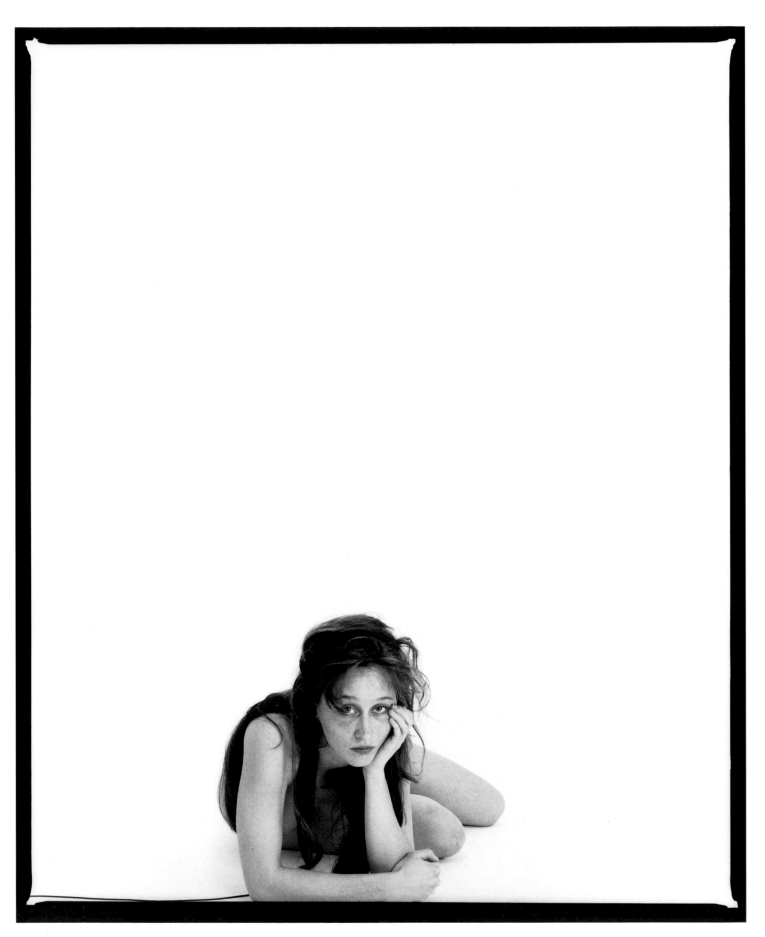

A N J A

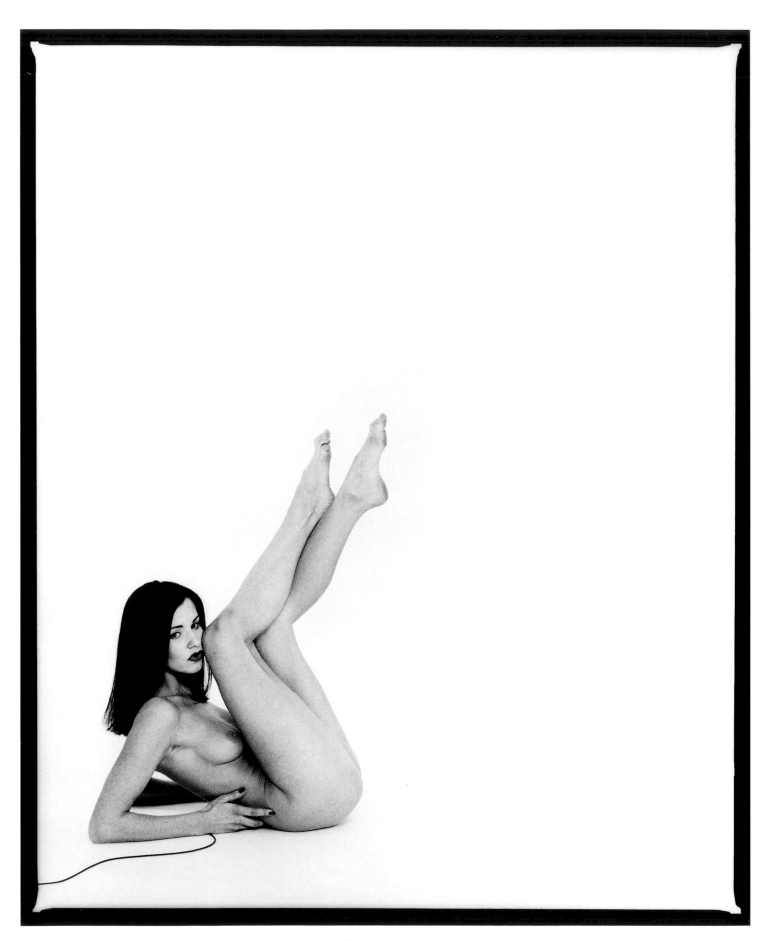

KARINA

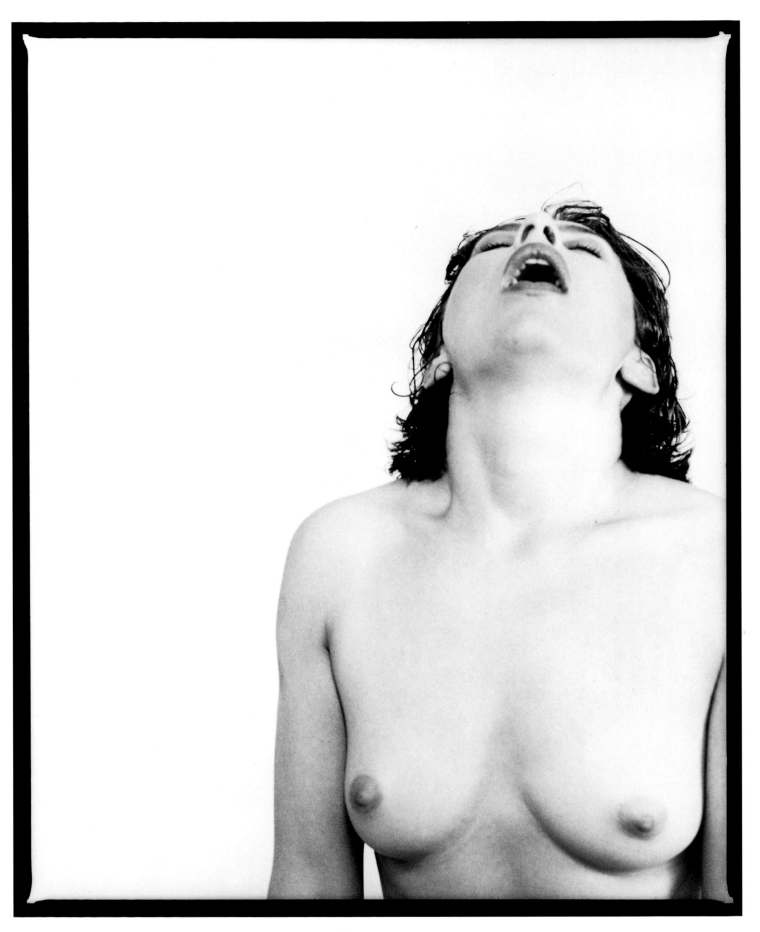

TERESA

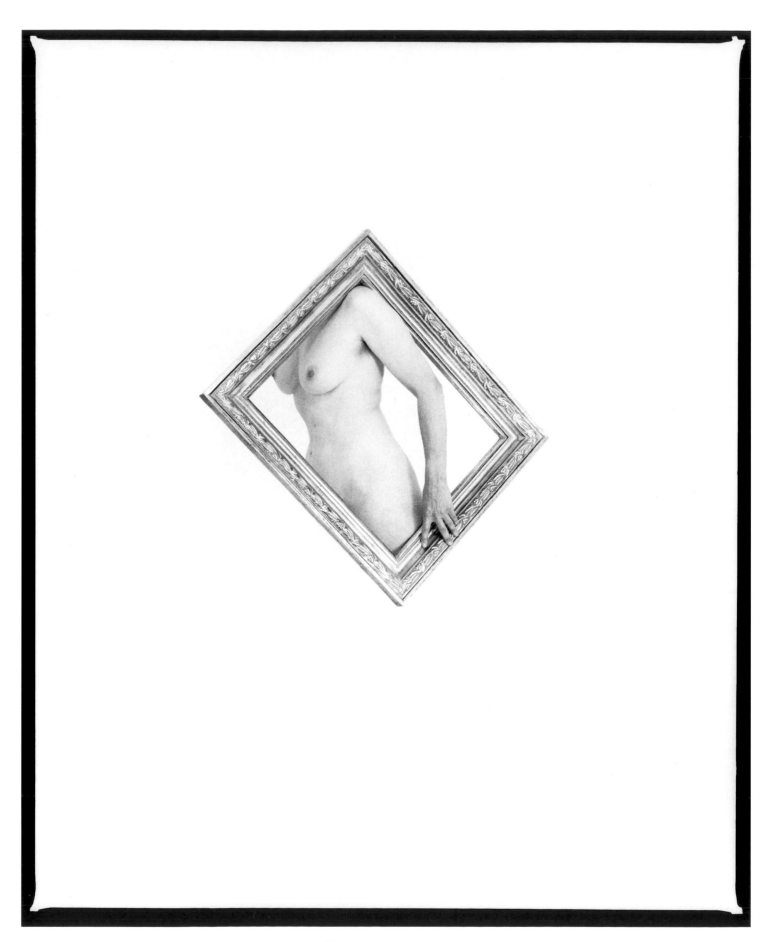

CHRISTINE

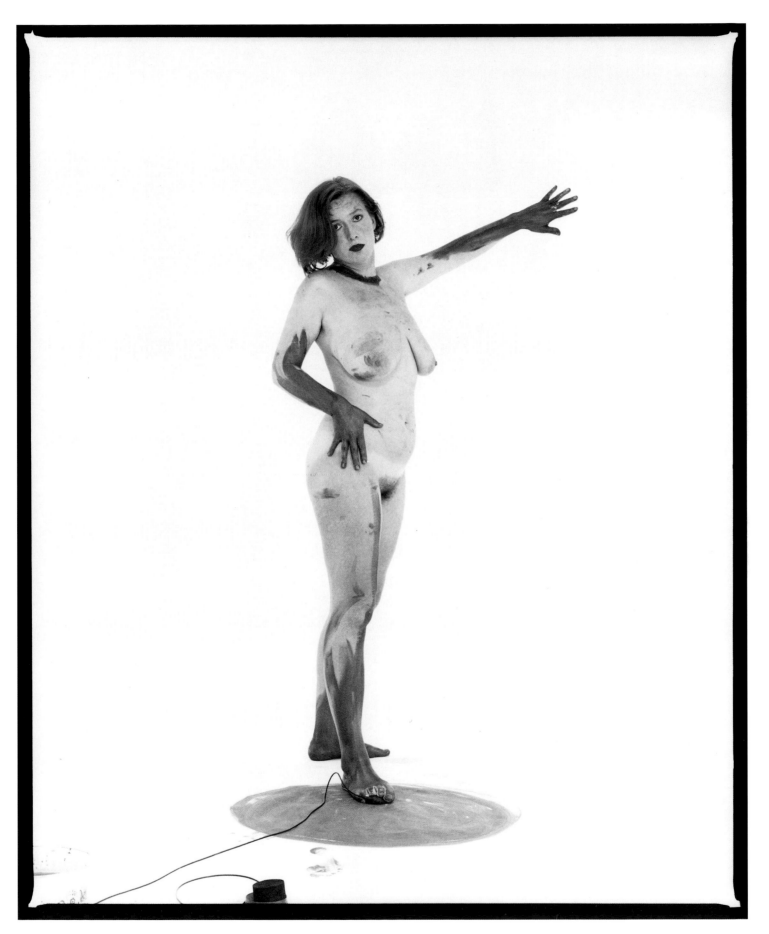

GABRIELE

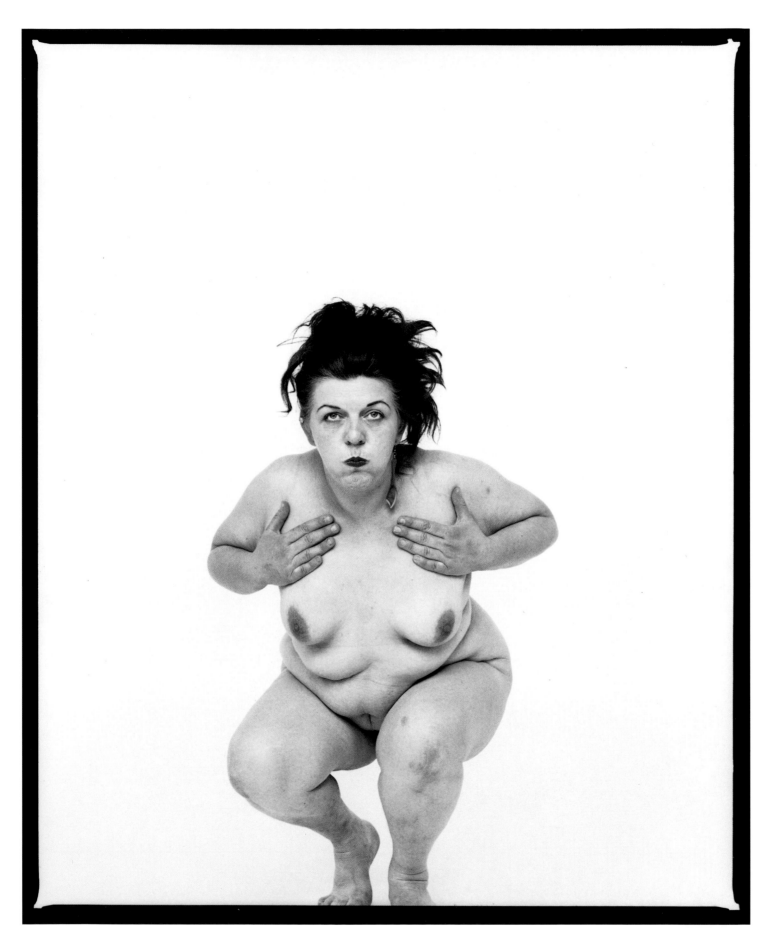

U S C H V O N H U S C H

93

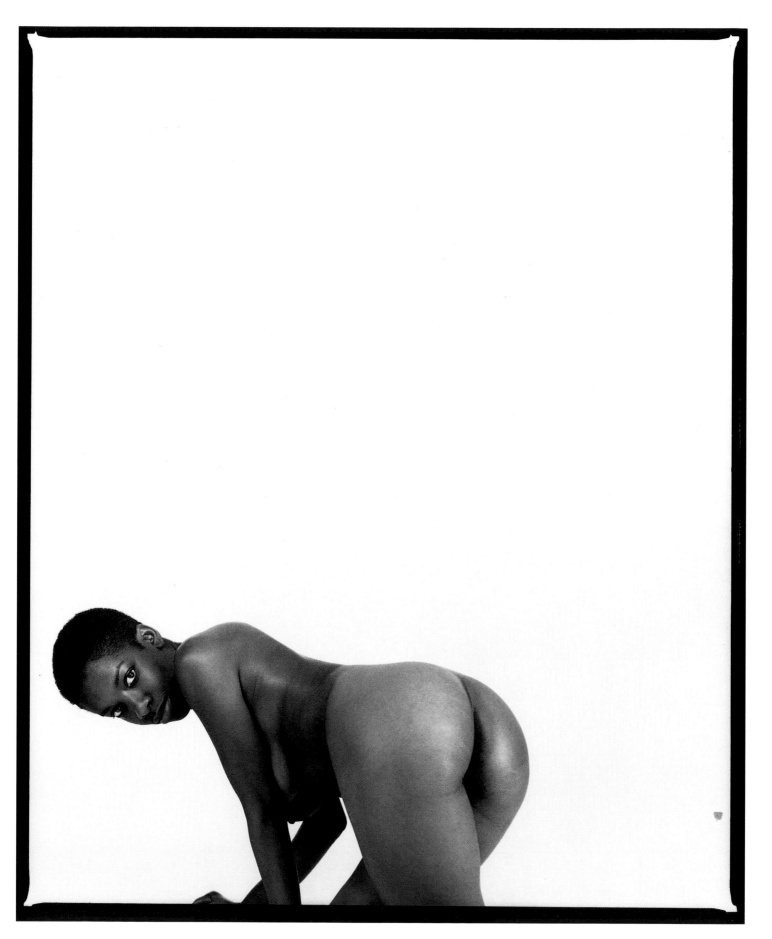

DONNA

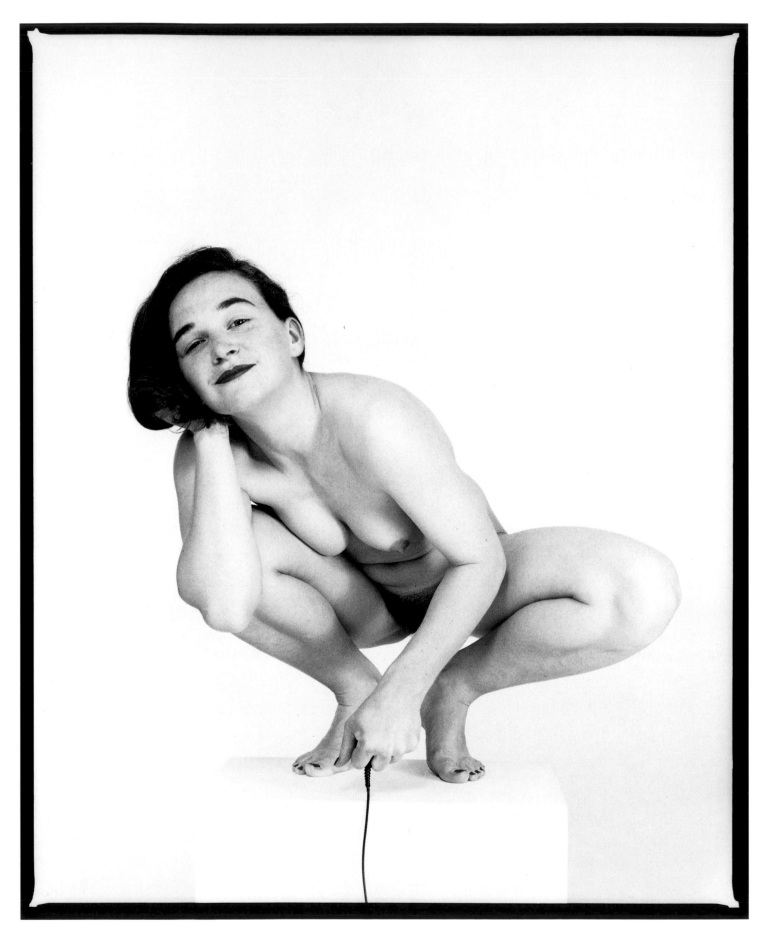

FRAUKE

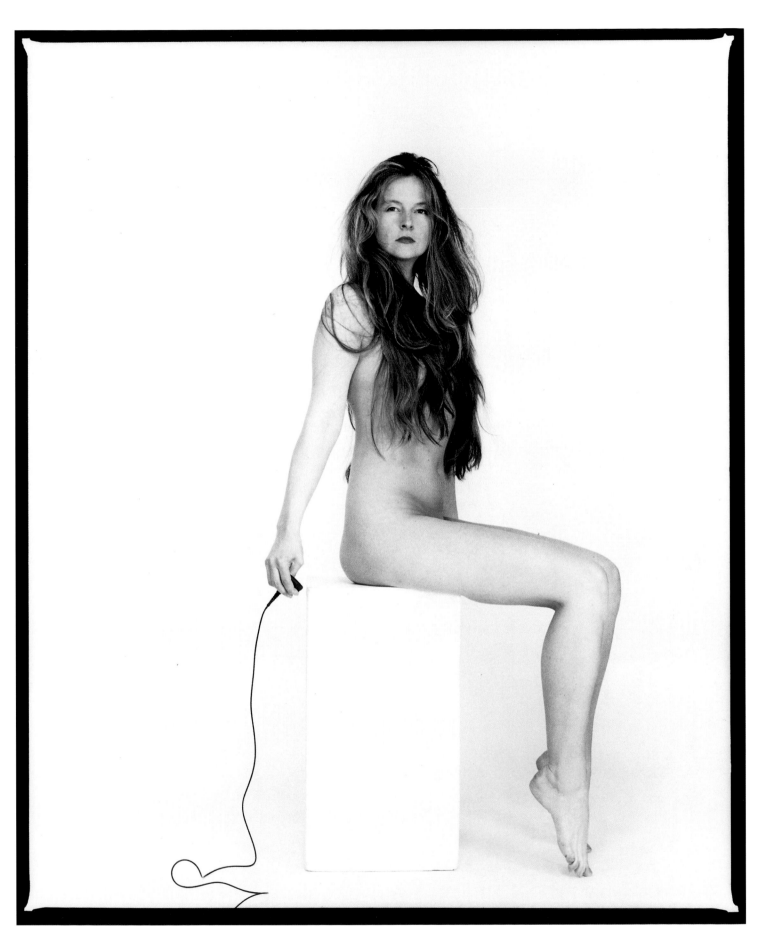

A N G E L I K A

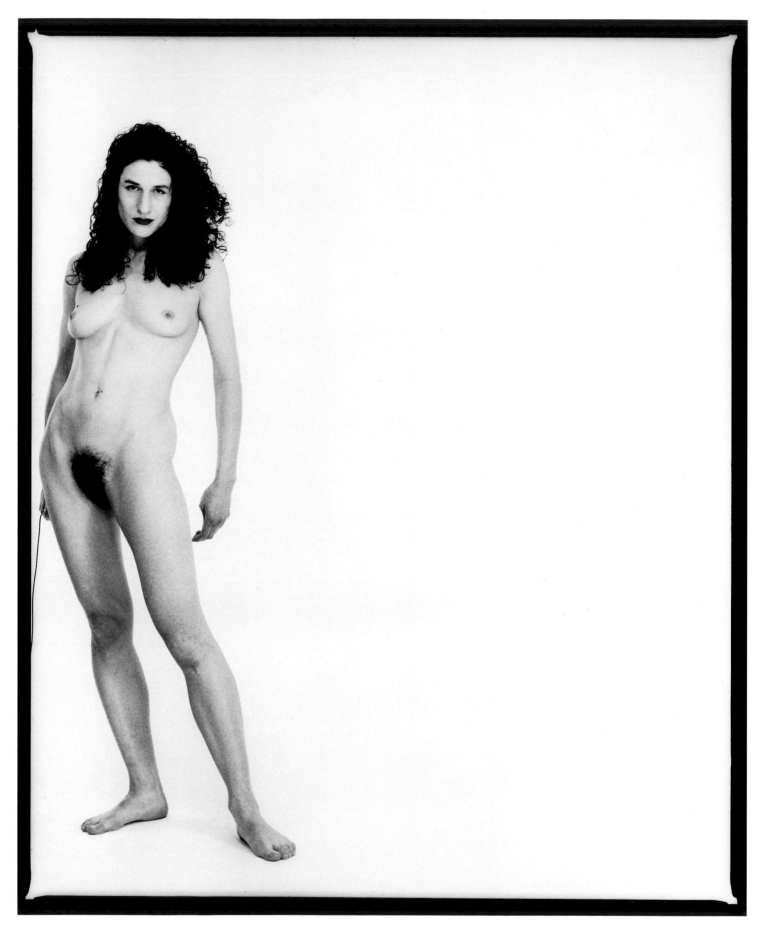

S I B Y L L E

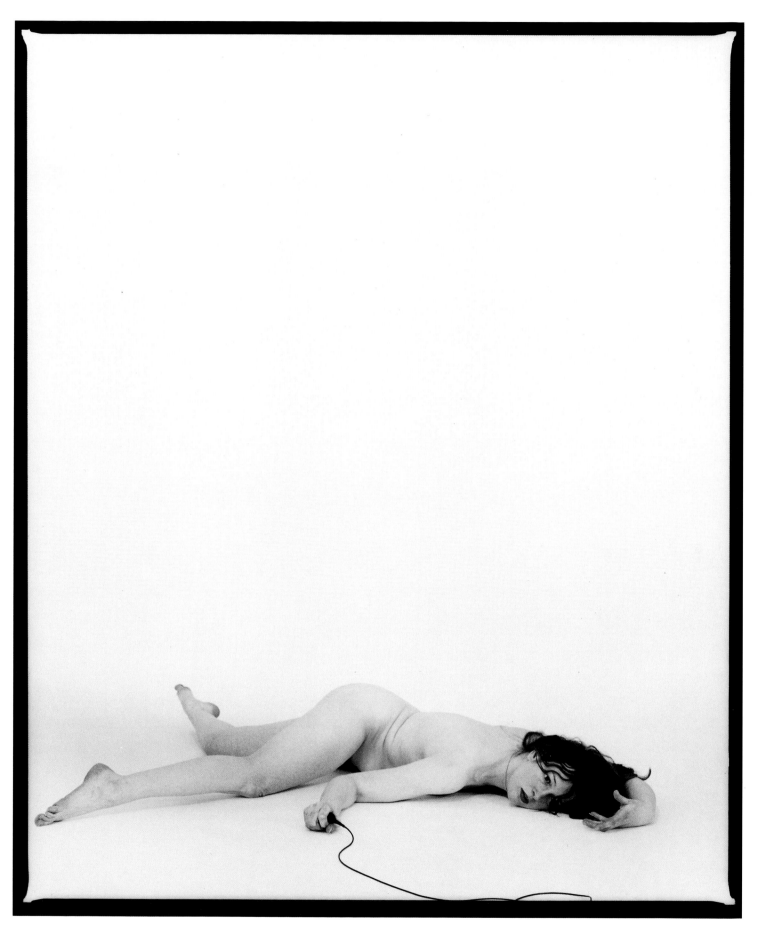

K .

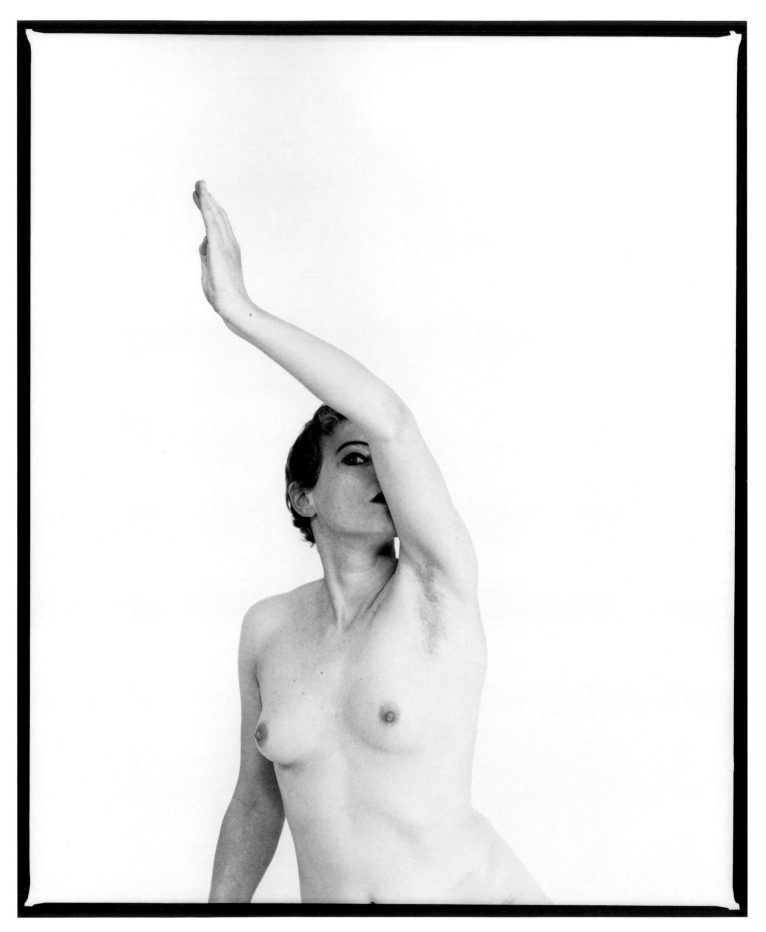

BETTY

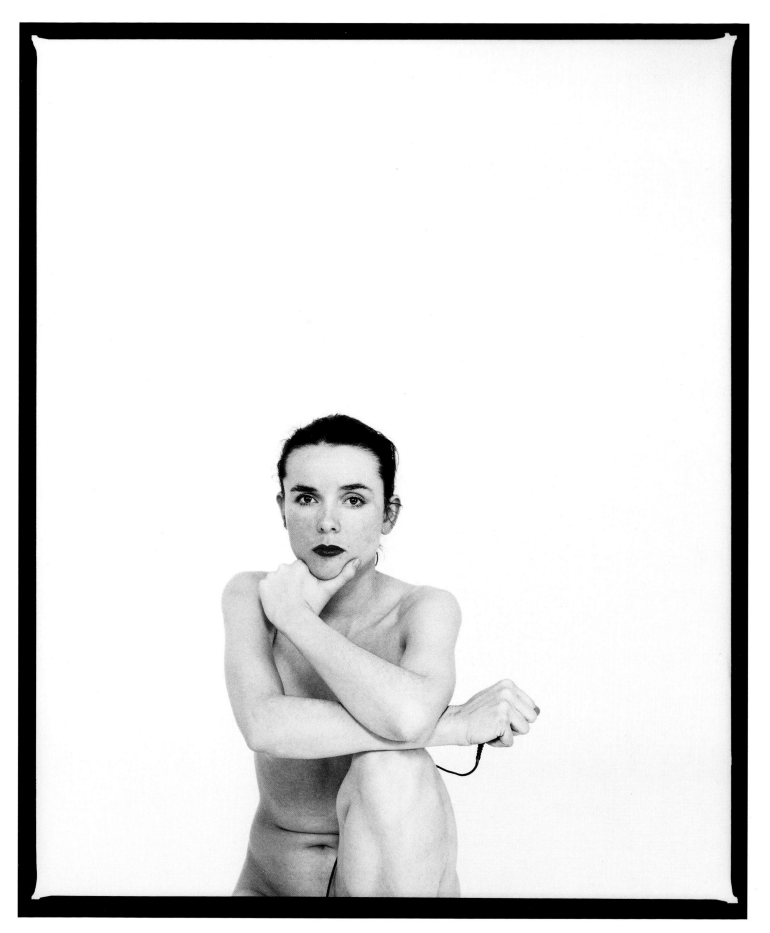

R E G I N A

101

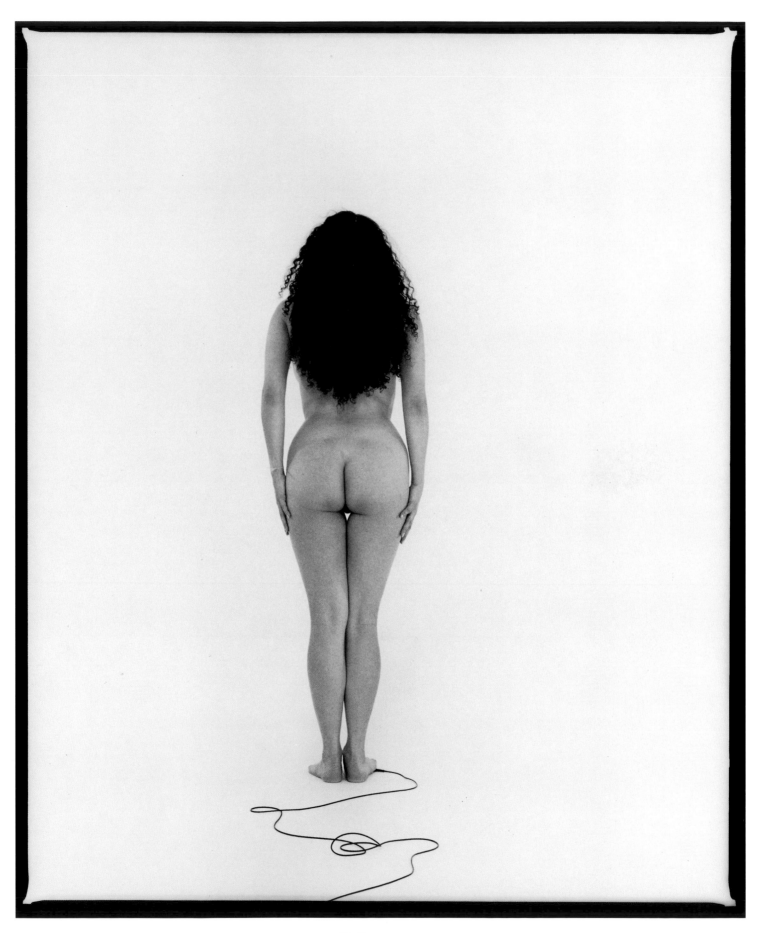

M Ô N I K A

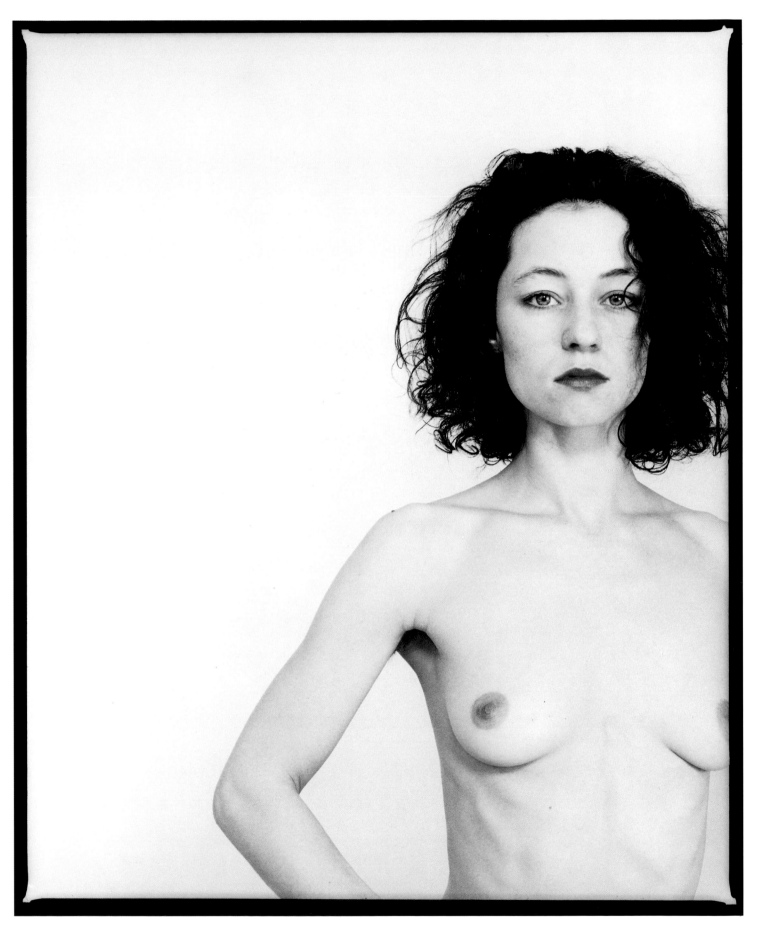

NATASCHA

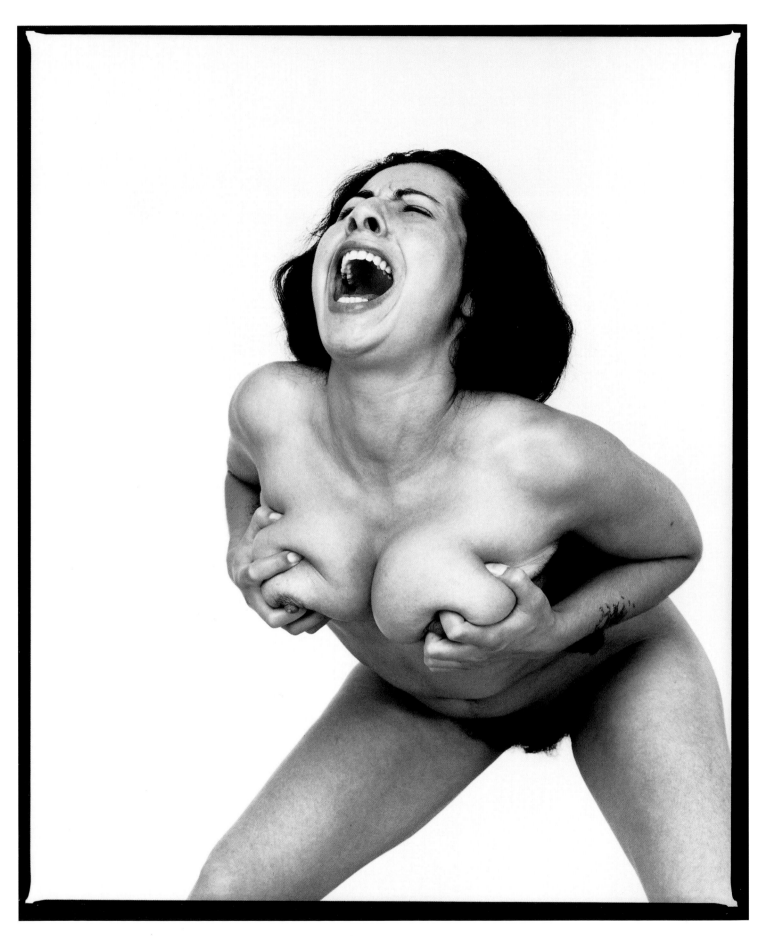

A N I E L A

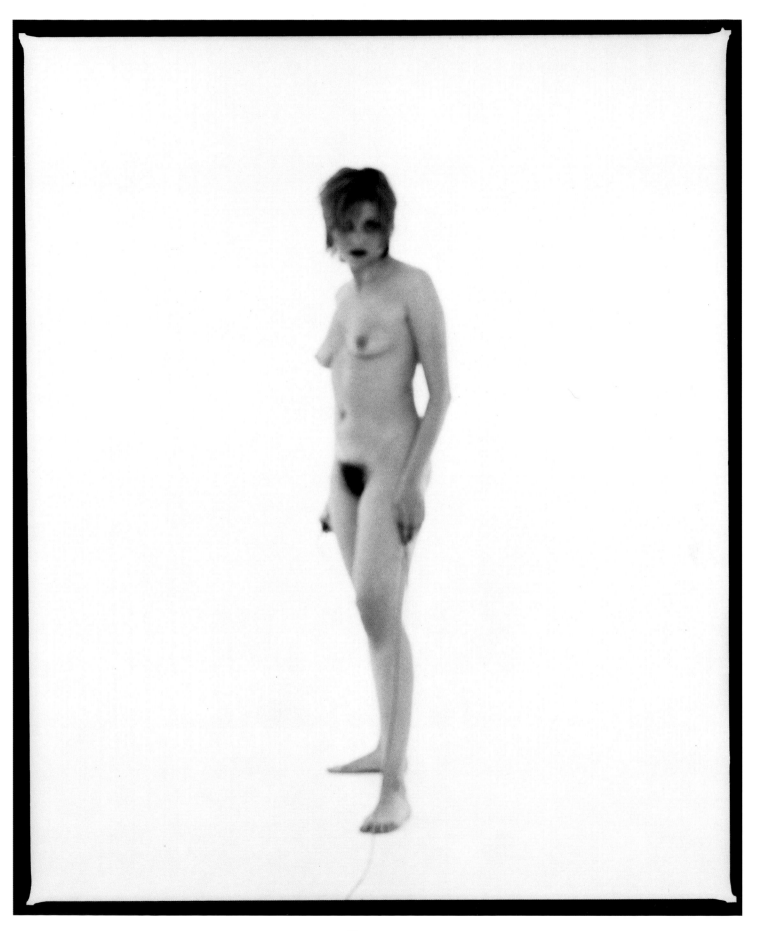

V E S N A

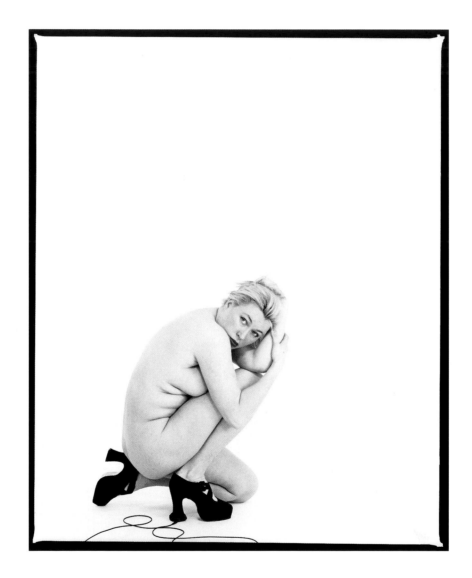

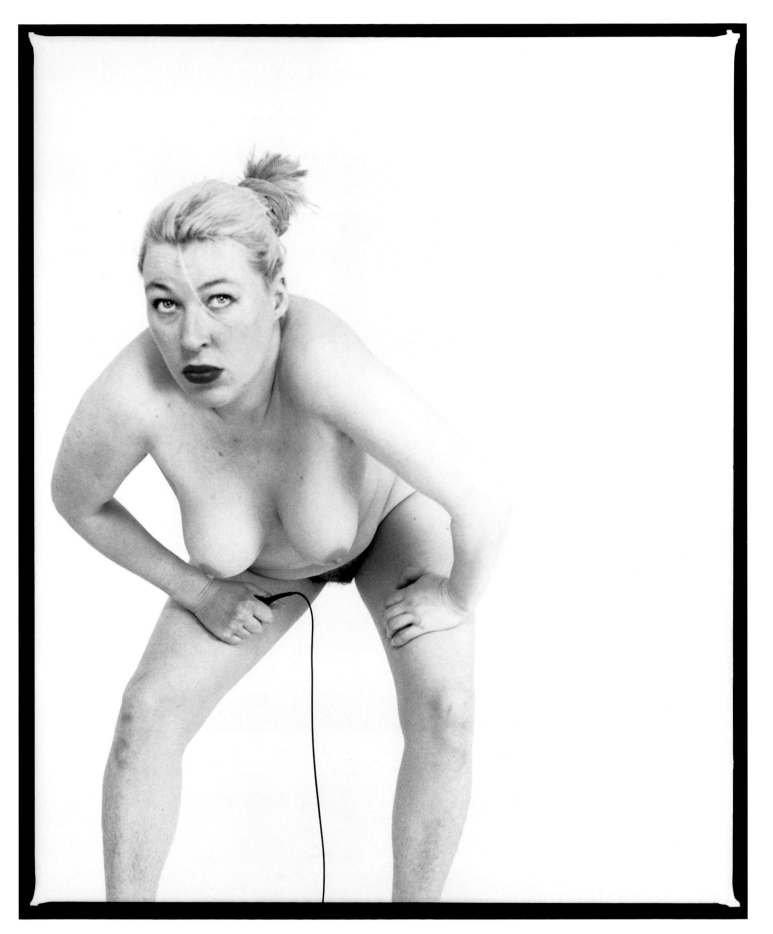

I M K E

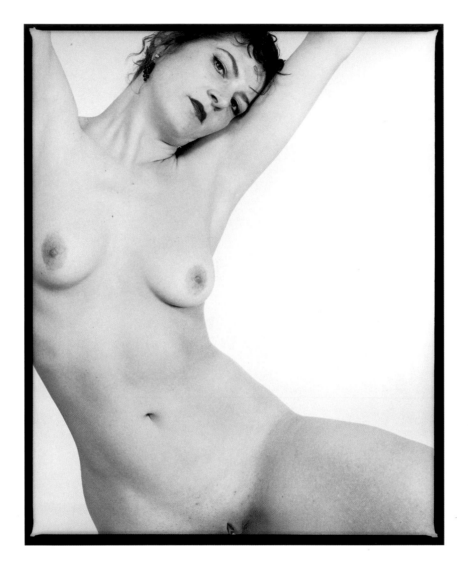

S I M O N E

111

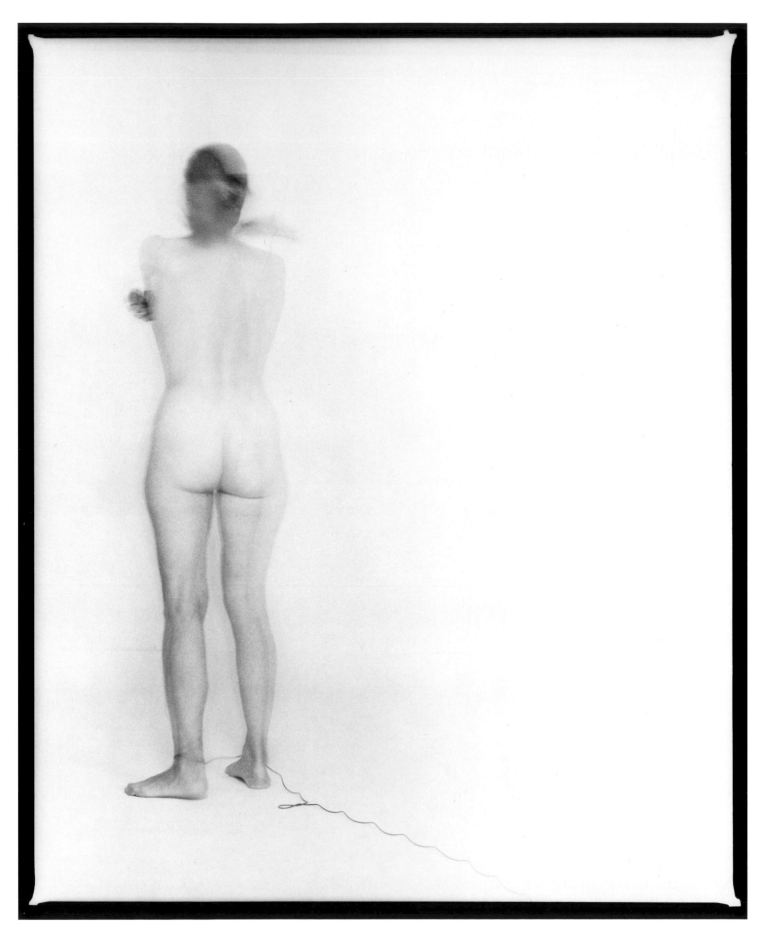

MARTHA

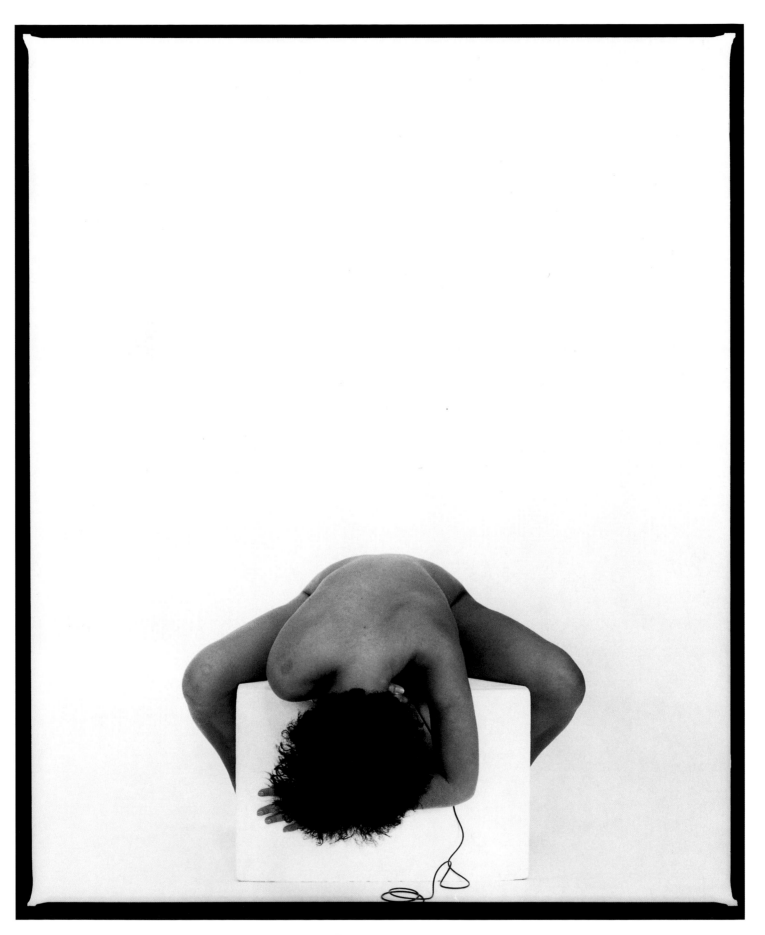

BRANWEN

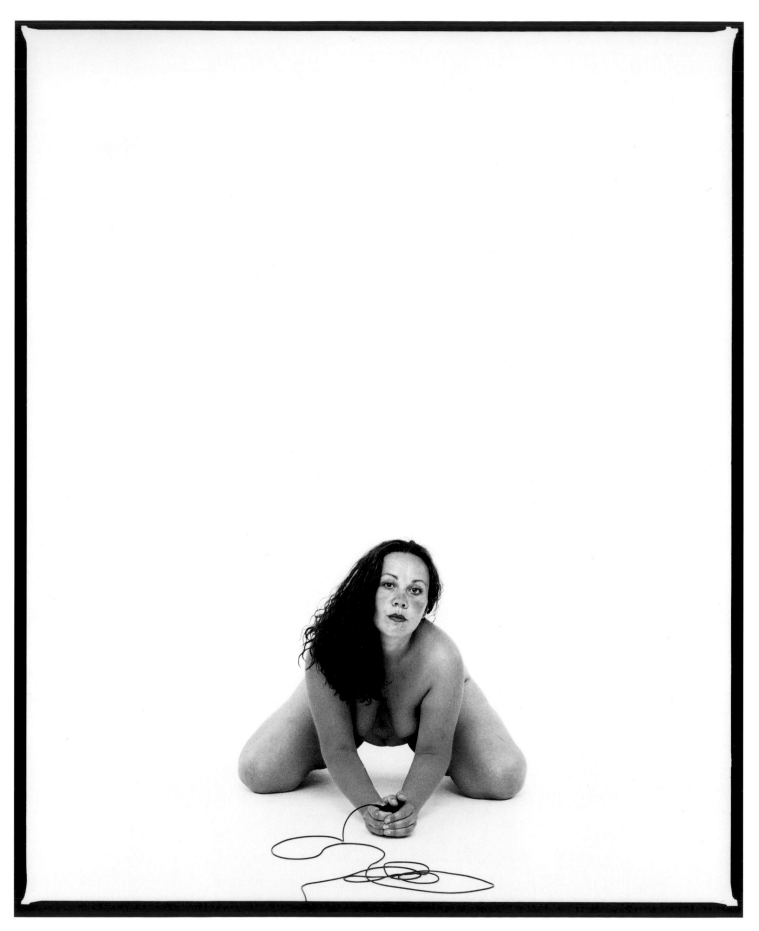

PETRA MARIA

114

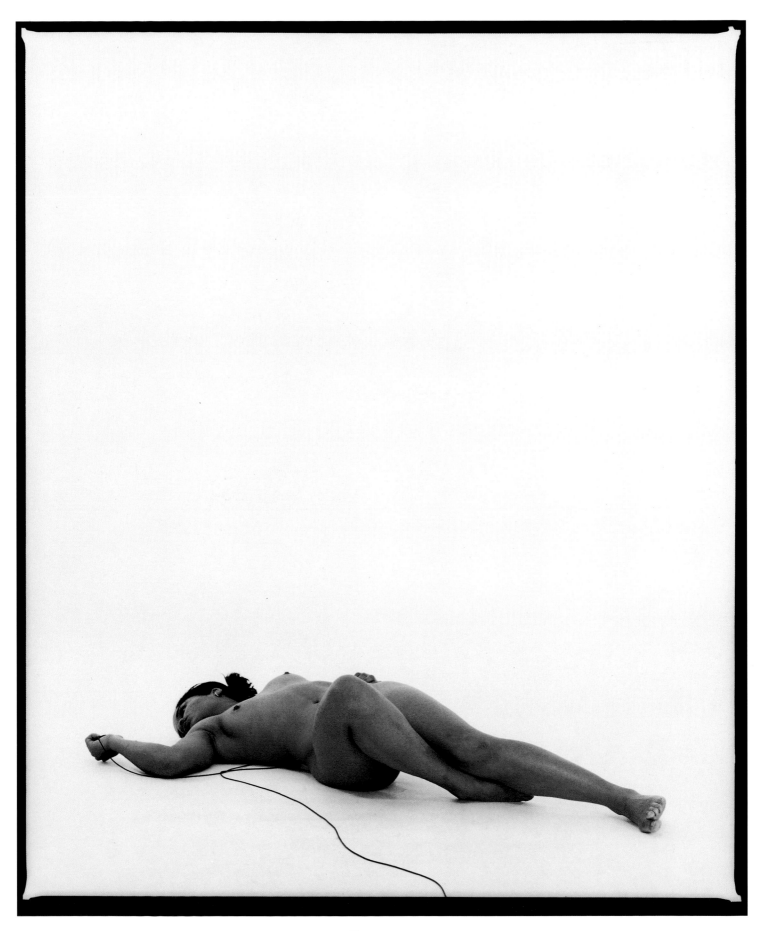

NAOMI

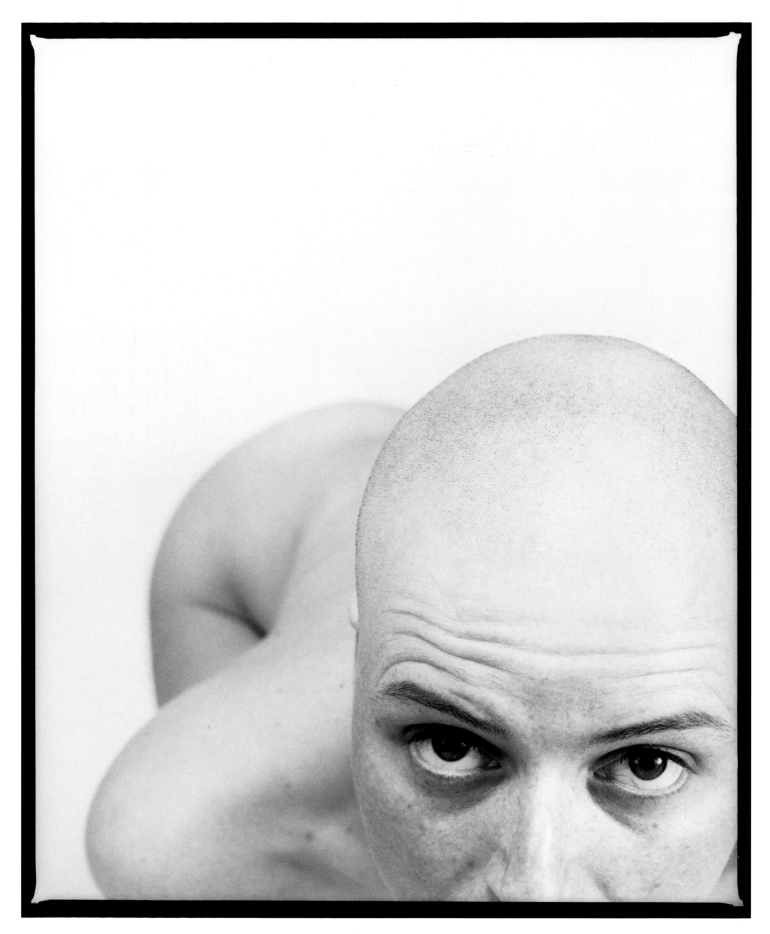

B R I D G E

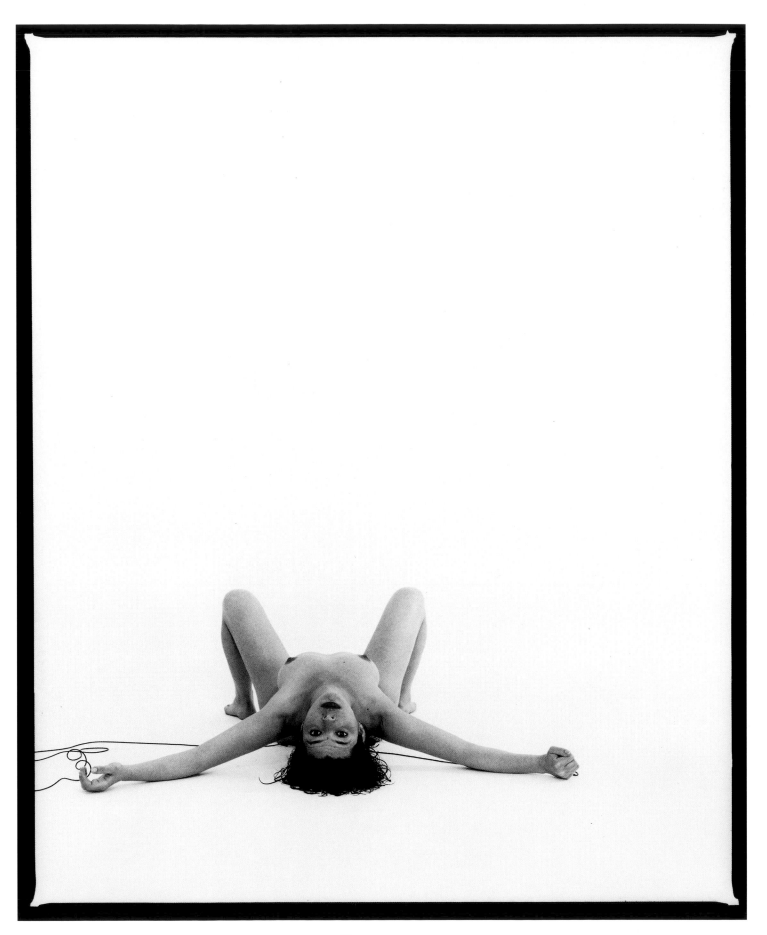

RACHEL

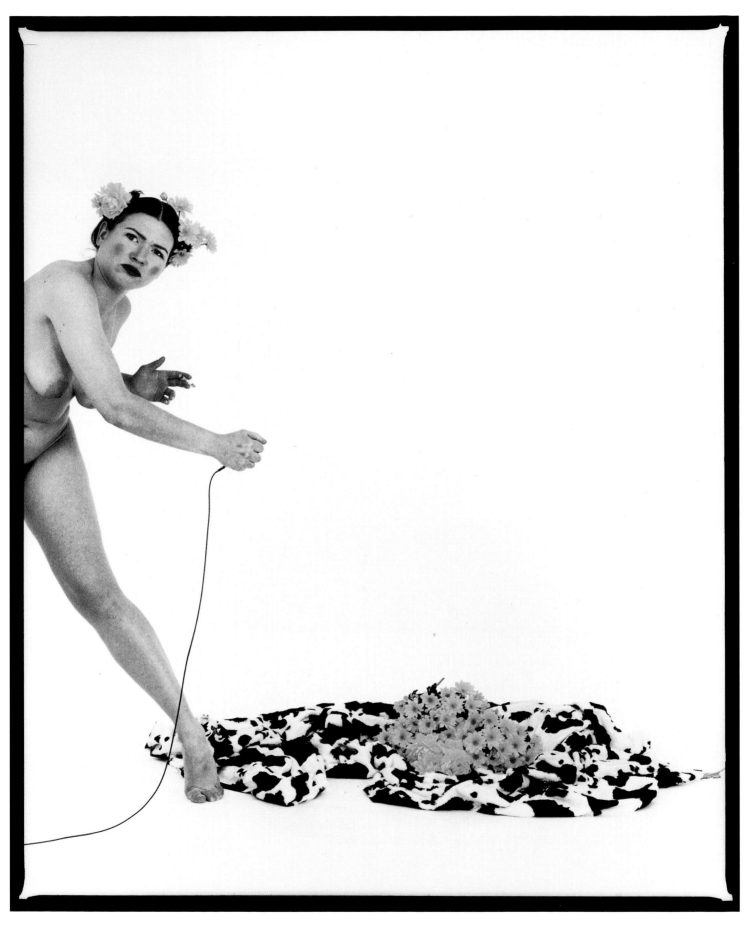

T I N E

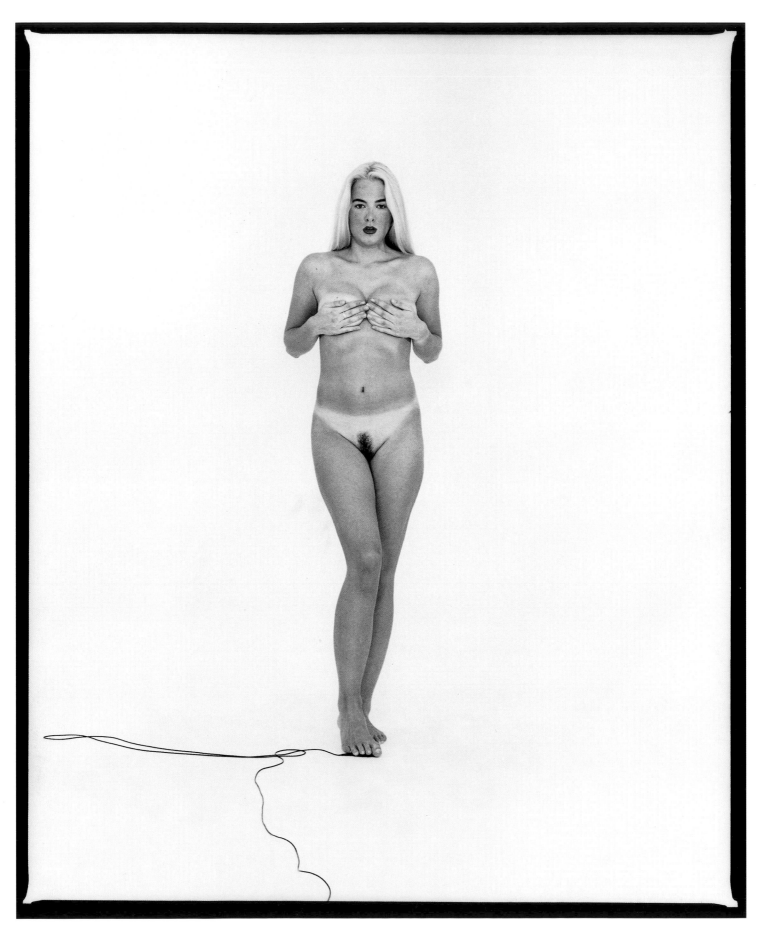

JULIA

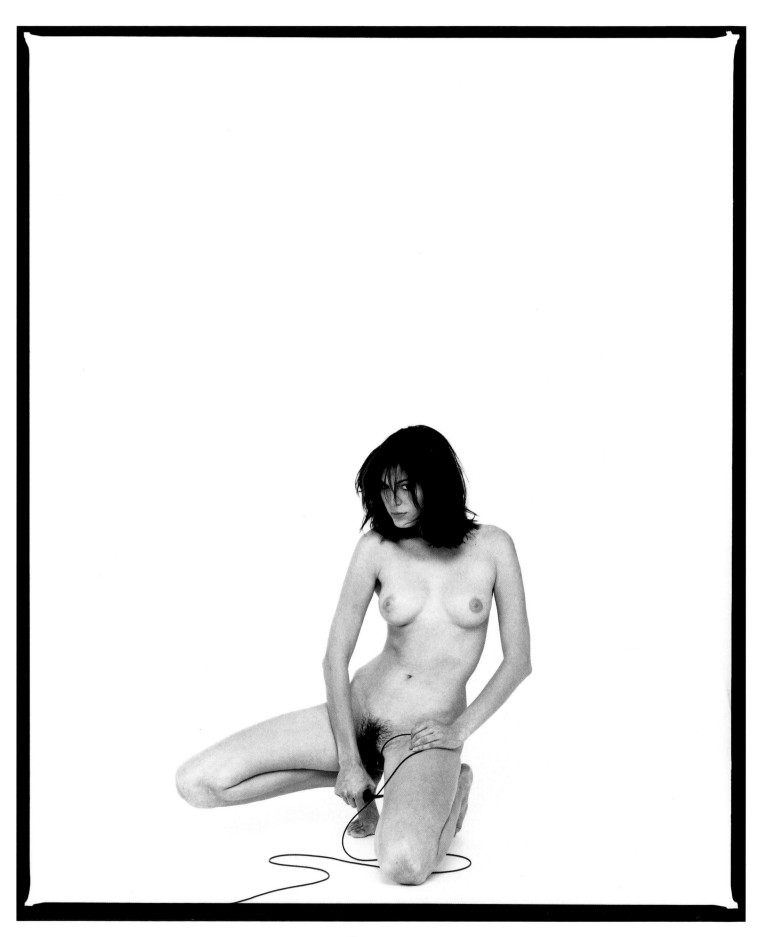

SONJA

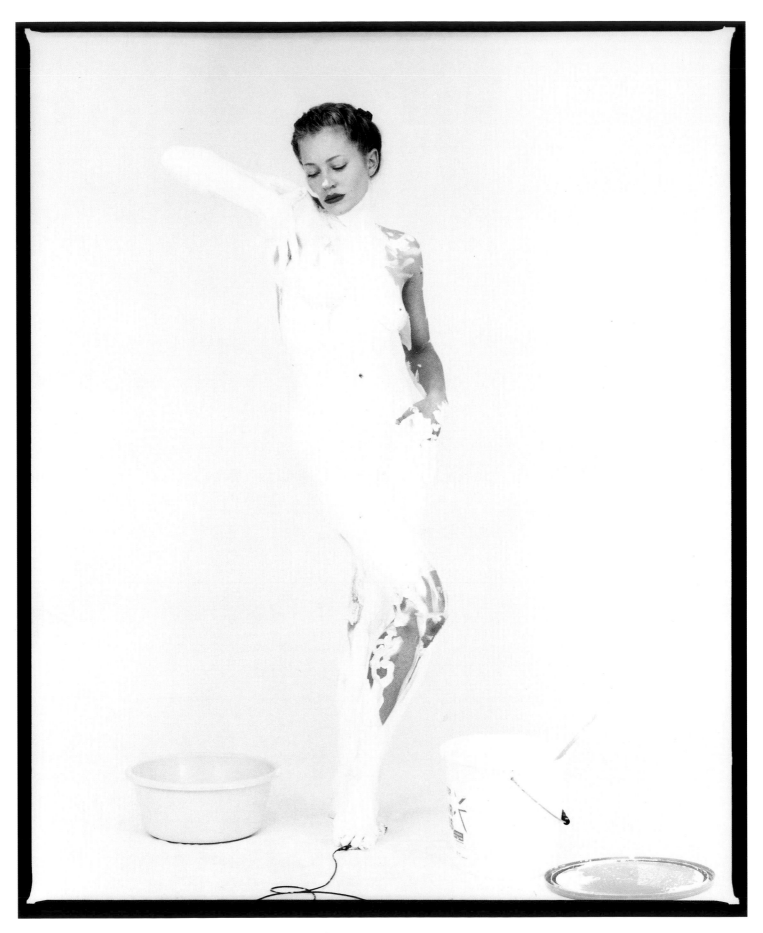

C H A R L O T T A

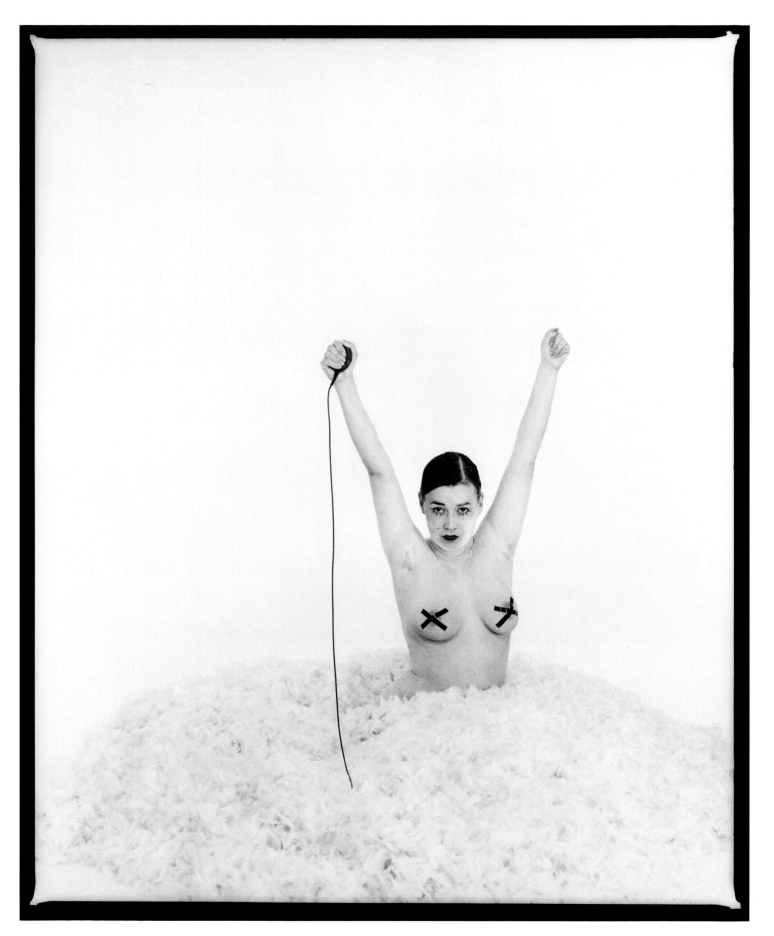

F I O N A

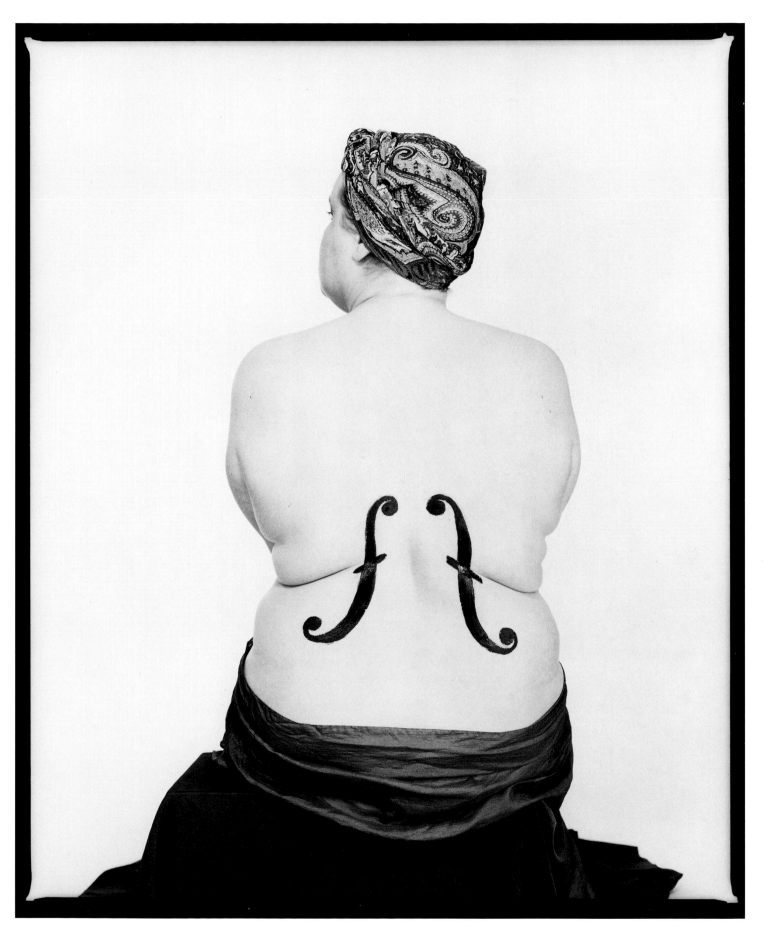

KÖNIGIN

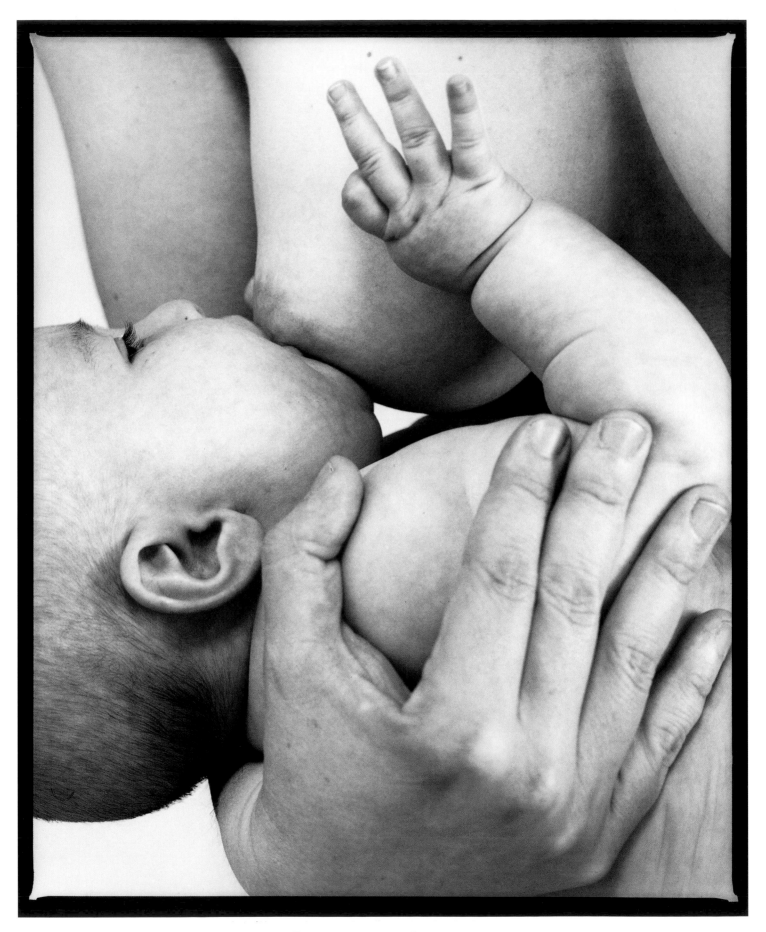

SUSANNE, LEILA

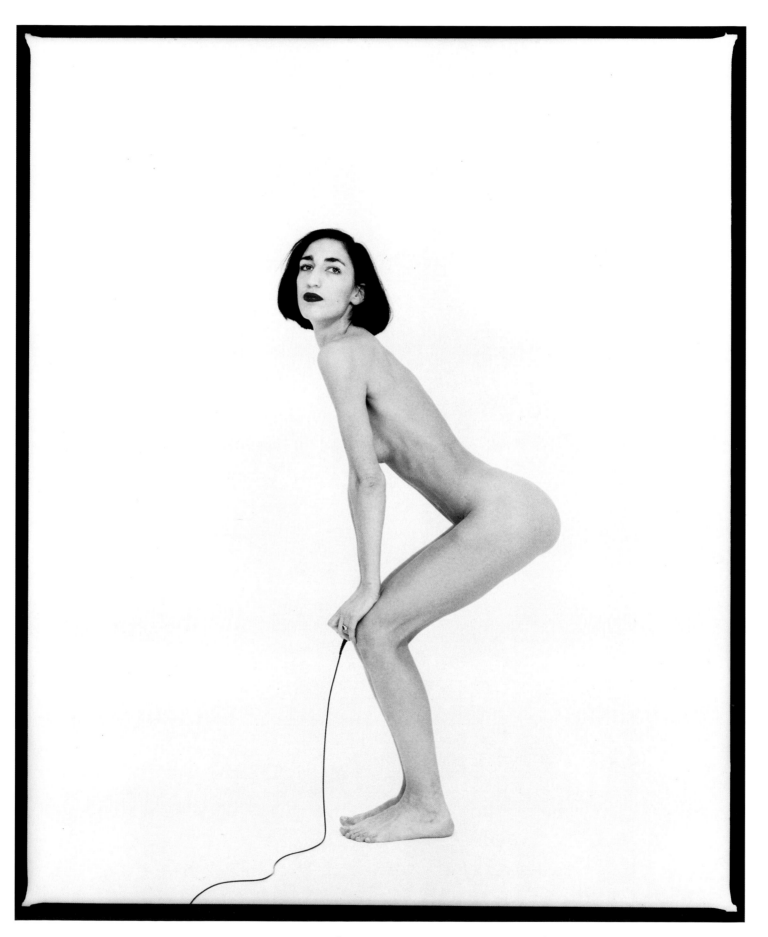

B ARBARA

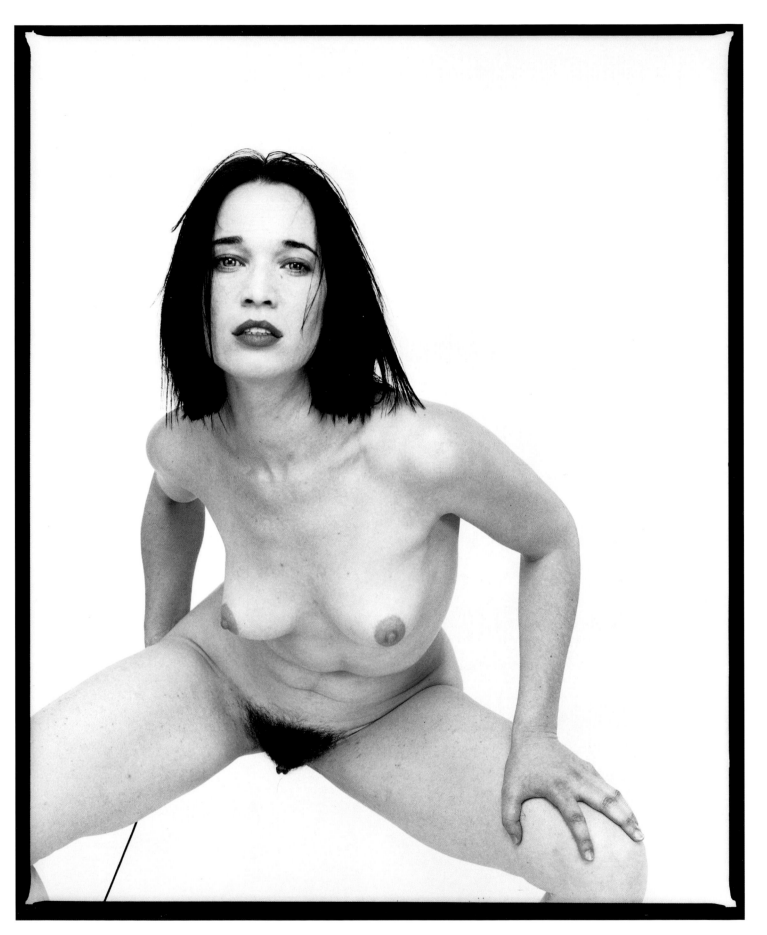

DARJA

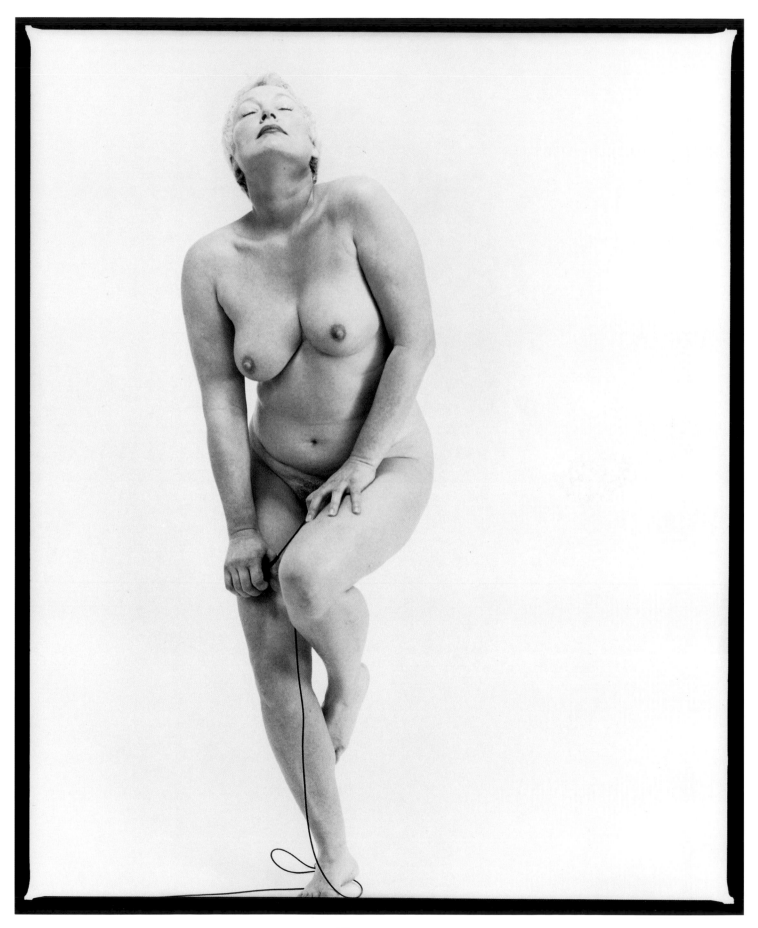

M O N I K A

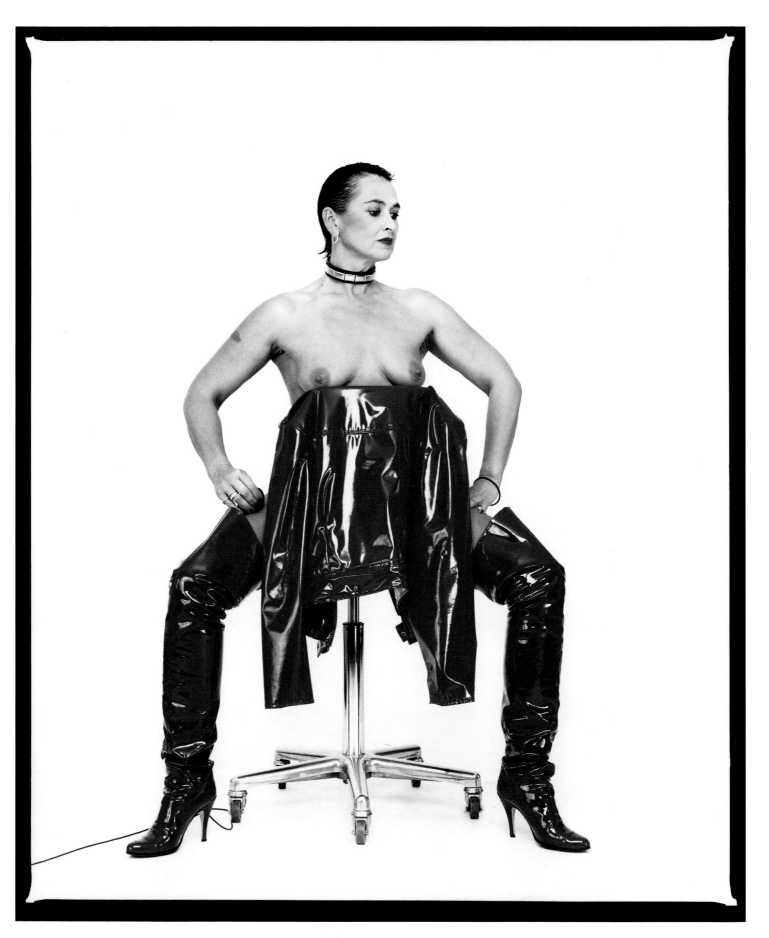

MARIANNE

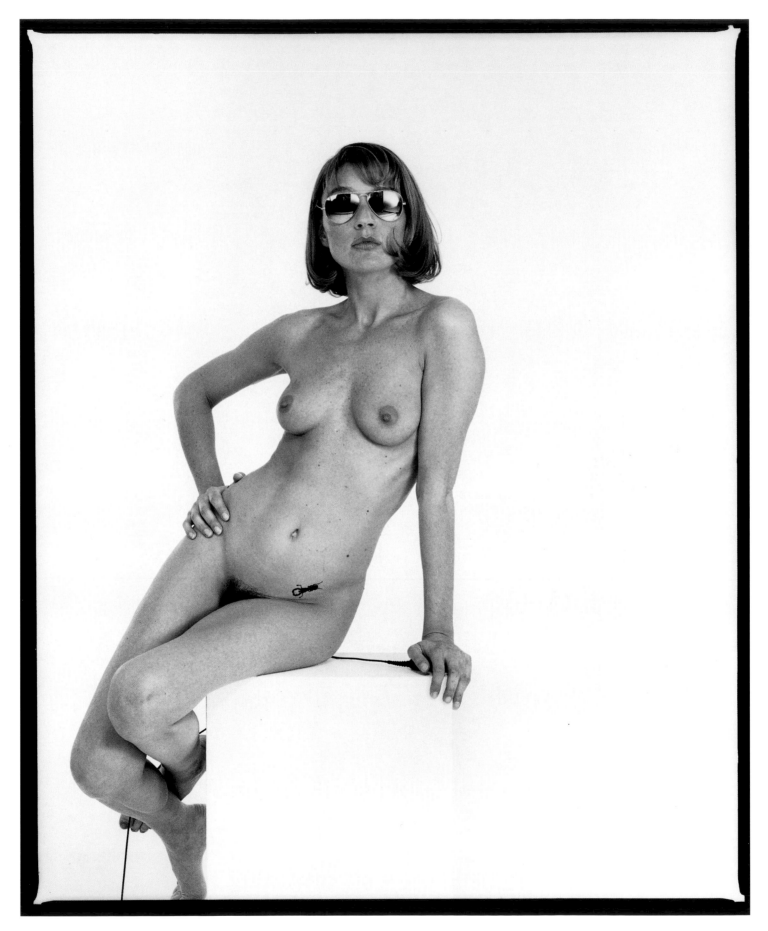

BARBARA

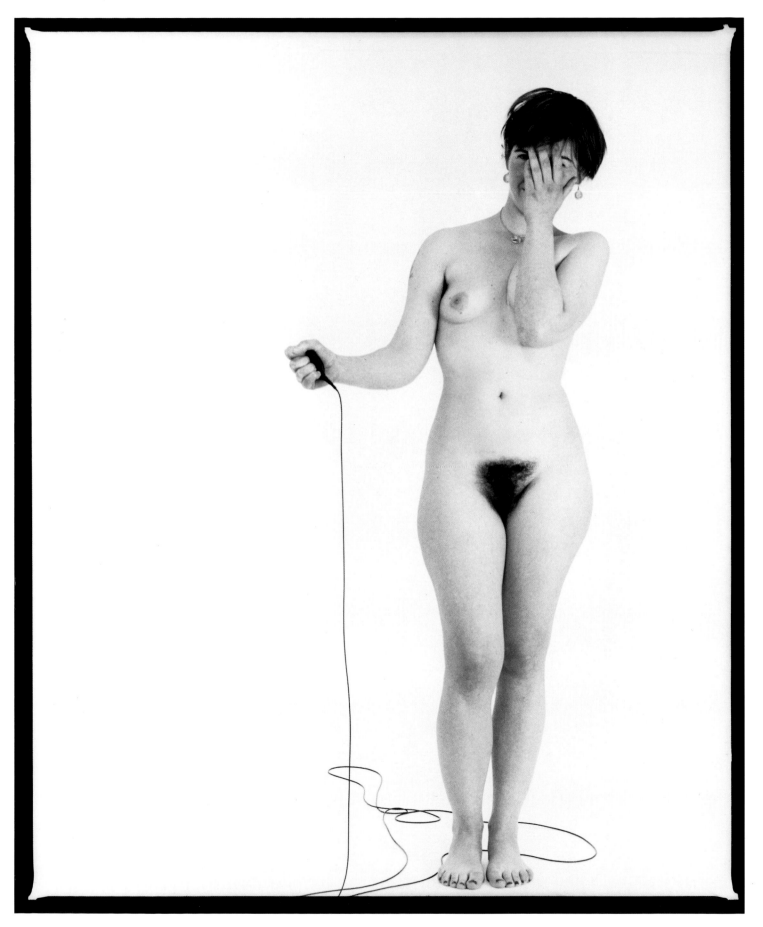

J A N A

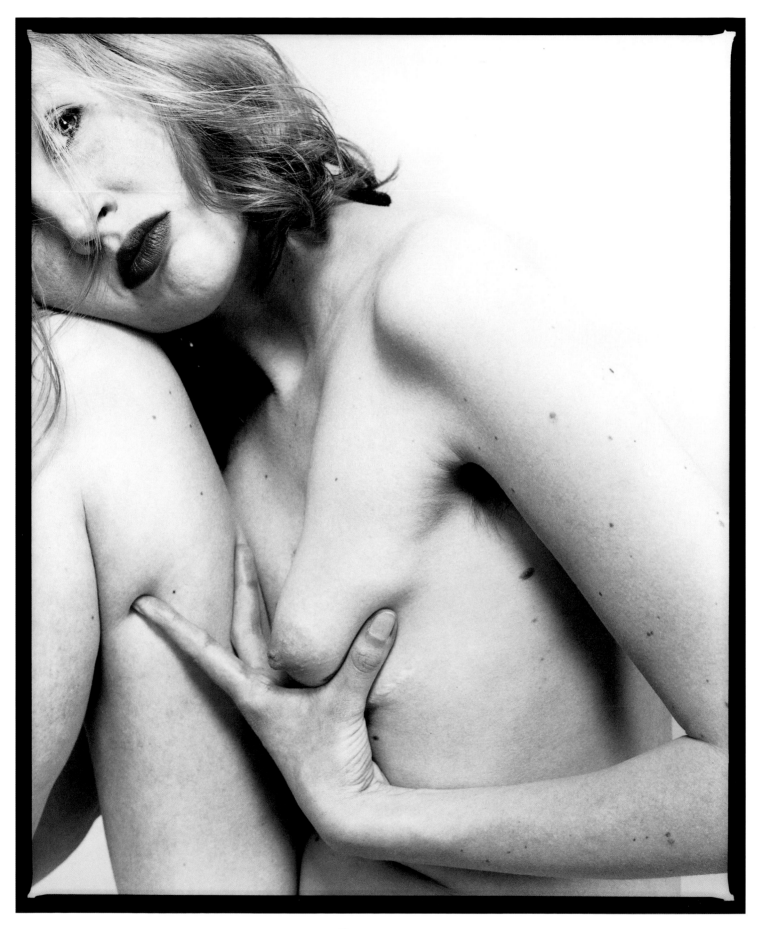

KRISTIN

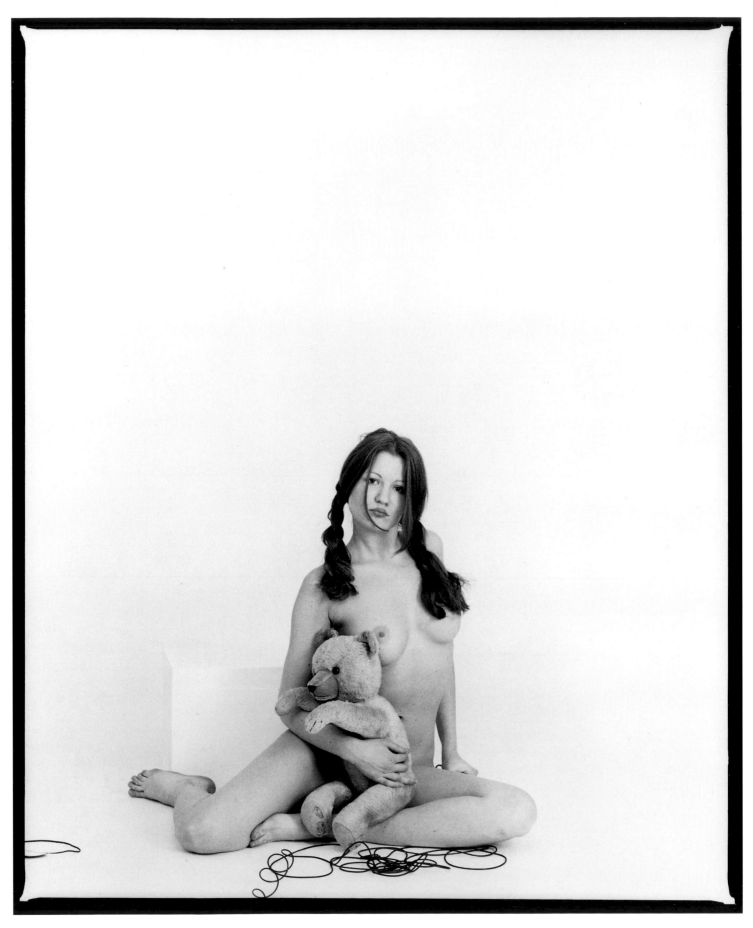

ULI

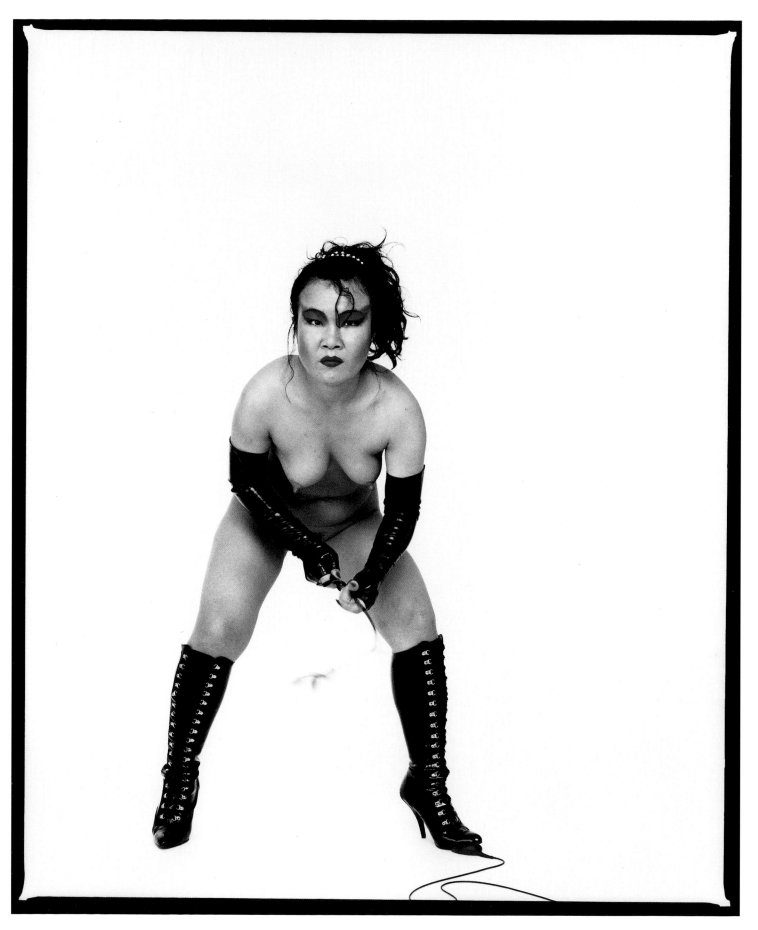

T O K Y O

137

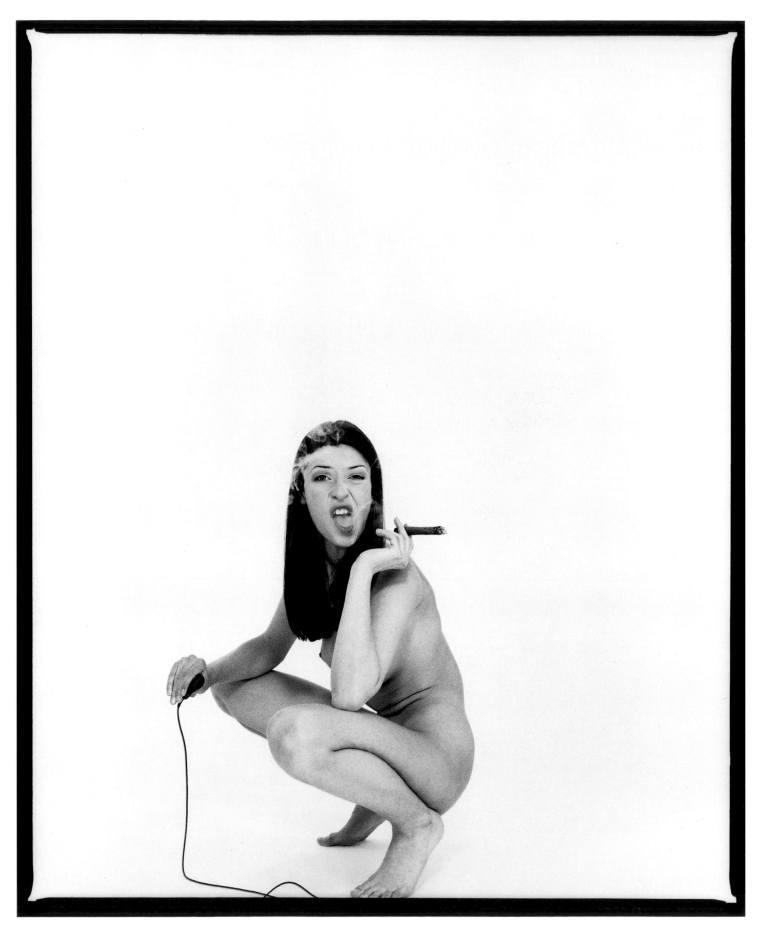

FRIEDERIKE

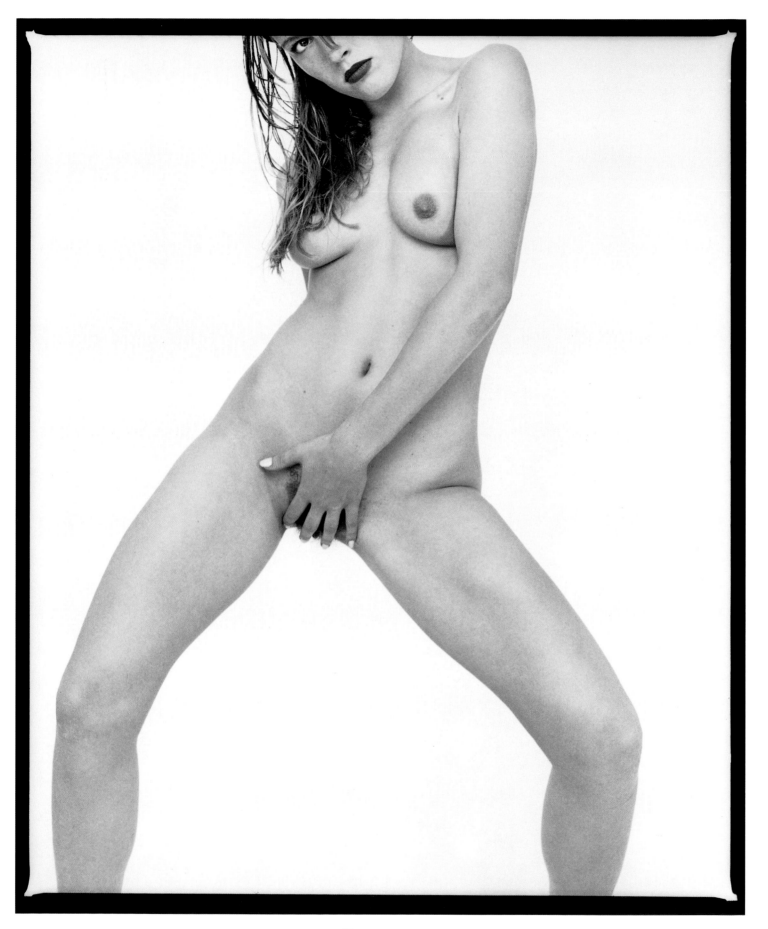

K A T R I N

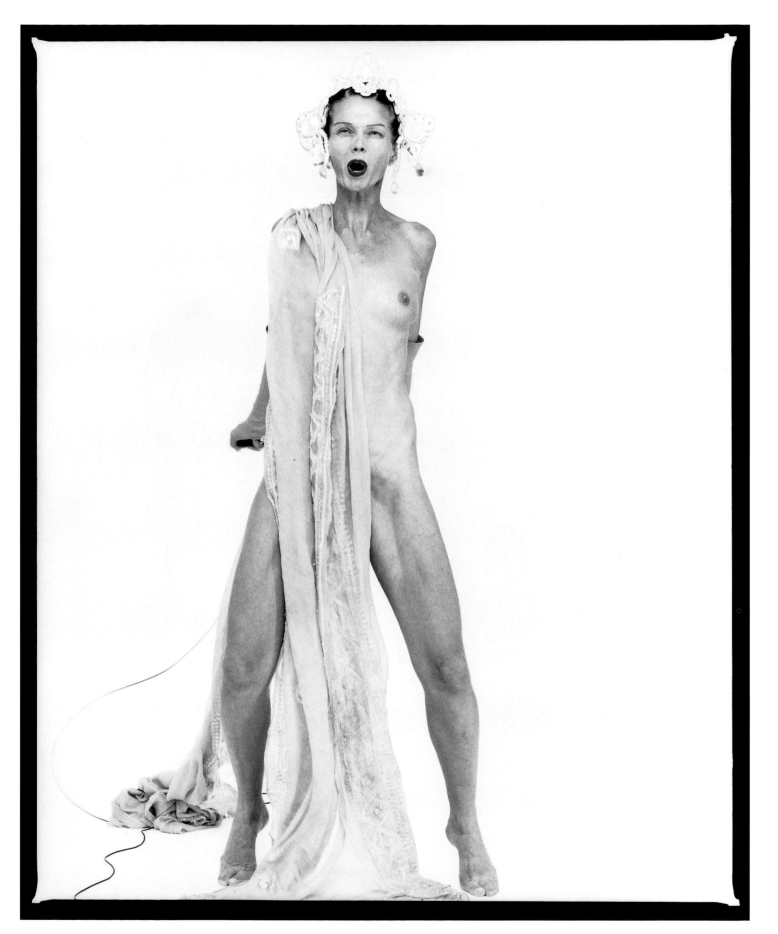

B R I T T

141

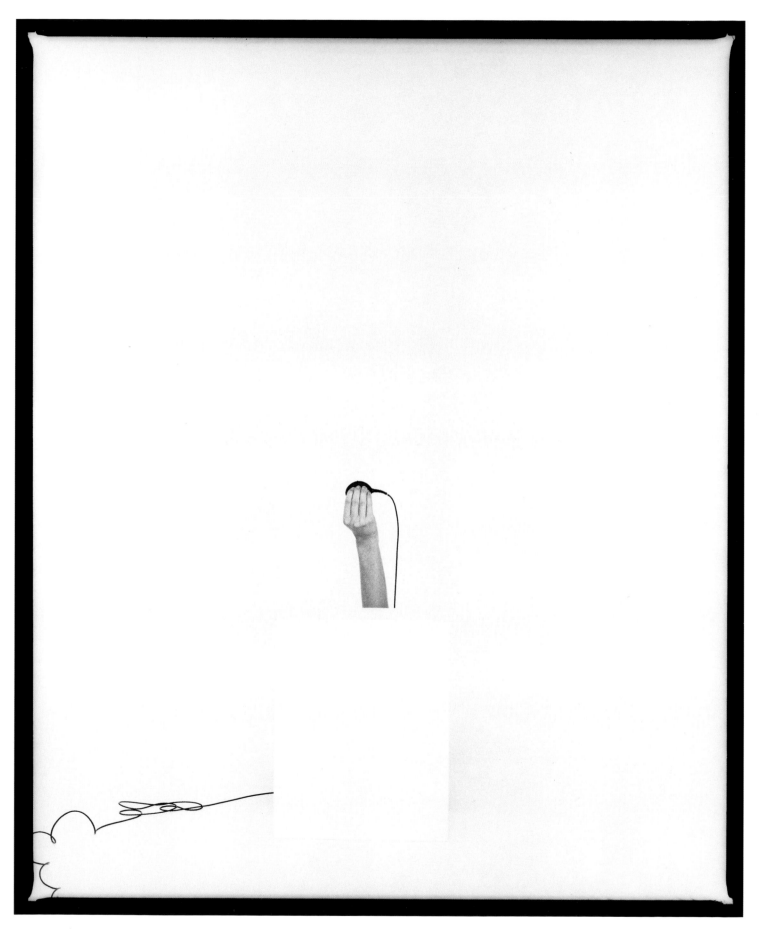

JULIA

143

THEA HEROLD
INTO THE WHITE

It was dark in the morning a child cried the mother awoke but that could only have been somewhere in the neighborhood otherwise everything was still she remembered yesterday when she finally lost track as they said and now she needn't trouble herself any longer with the hundred lost women's stories she was always carrying around too little for her book but too much for her insides to bear

Yesterday she had rushed out and abandoned it all and come here where she always came when her brain was burning or her sex now she hadn't been here all year and found the door bound shut by twines of goldenrod and stinging nestles but a late jasmine was still in bloom

It overpowered the slight musty smell that hung in the room like a half-dried pretzel and because the darkness came without delay she fell asleep early next to the stack of the hundred stories

When the child had calmed itself and the swill-bearing tractor and its high-flying aircraft had been swallowed up by the morning she went over to the mirror suspended on two lengths of cord in the center of the room and saw herself in it as if looking at stranger she looked herself in the eye and reason sought once again to grasp the big why

At this of all times when she thought it had finally been found and it turned out though that it was all for nought Only just this morning she suddenly understood why and this understanding came with such force that it hit her in the forehead almost like a shot so that's what they wanted of her

Those pretty little stories about fashion cosmetics silk and fur flap simple to read pleasant at tea or after dinner full of heart-fat and warm soul all nicely garnished on a platter larded with décolletage stored via mod seven and elegantly formated and written on floppy for the sweet moment during the week or the panting five minutes before

She tapped her forehead in the glass the mirror swung gently on the cords she walked around it and to the window she leaned out naked as she was an ant came from outside ran across her arm and down over her and between her cheeks and bit so hard that it began to hurt and not only in her head she groaned and felt like crying of course she could go ahead and do that if nothing else was going to turn up today no one here would be bothered

Outside the window a blackbird began to sing silencing the thrushes finches and starlings in the other trees the woman lifted her head of course she couldn't see anything but water it backed up behind her eyelids but she could still hear clearly listened in the direction of the black-white trunk of the single birch from which the blackbird sang

You've got it good just singing your song with your own tune and I'm listening and watching and I am glad

She walked about the room she took three steps towards the bed four steps towards the door five steps once in a circle around the mirror she had tied to the ceiling at some point in order to liberate herself from its enslavement back when it helped to spruce things up a bit

It hadn't helped much of course in this world in love with its mirrors she has not become a different woman no different than other women who decides anyway what a woman is as blind as men have become and we not much better because who is it that submits to fashions as if throwing oneself beneath the grindstone wheel and what is this insanity we pour ourselves full of about the sense and purpose of gender this stuff pulled from an old chest full of mouldy bluestocking rags after all we've been trying to talk about this whole business since Adam and Eve

Maybe what a woman is can be better said by a man it just might be possible or is it unthinkable for a man to unearth the secret words the woman asks herself once again she looks at the pile of paper the mountains of white sheets printed on one side with thirty lines of sixty characters each she remembers the months days and weeks when she locked herself in just so that she could get to the real words and all the stuff she had to hack away from that clump of claylike ore in that time of unmentioned gradualness

Gradually and only women understand what it means her lust for the unspeakable grew she had wanted to track down the women's stories as if time belonged to her she had taken no artificial light lived according to the seasons slept late in the winter in the spring she was up early and in the summer she let the telling ripen under her watchful eyes to the very last word

Finally the many forgotten love-struck injured moments began to burn she saw them flaming up in the colors of autumn and a few women offered a glimpse of a last secret phantasy like light coming through the leaves of the trees Never did she come on with those modern numbered precise questions the plus and minus of the statistics hinging on the where from and the where to and with whom anyway she'd much rather just have listened nodded once and a while even cocked her ear in amazement just like that blackbird outside in the tree but she never could have imagined saying to one of the women oh stop you're lying

There was a tunnel of approval you are as you are and once that had been made clear and the clothes had fallen away she would take the one and another time the other quietly by the hand and lead the way into the white

That white was the greatest temptation the most beautiful gift the best accomplice the most discreet friend the most revealing mirror of love and hate and the most wonderful stage for everything they wanted to tell about sometimes they hesitated or cried out some hunched over contorted twisted or lay frozen and sunken into themselves or relaxed not just a few had dug the nails of their left hand into the back of their right or holding onto themselves for support clawed fast to their own breast

She remained the dumb listener was a sister wet-nurse mother lover confidante a womanly nothing of everything The woman thought of that year until the blackbird flew away and she peered out for a moment through her washed eyes towards some sound the way people's gazes are drawn to a bell ringing from the church tower

But now the year was over good morning lost like the book oh you lovely and the day the first without writing would pass through noon evening and night she stood up from the window and went first to find herself a dress

To find a dress in her color a nice material with folds that would envelop her in joy a nice material with folds she could hide herself in a nice material that would take her in like a vast ocean that whispers and rolls that she hadn't done for a long time

Sometimes she dreamt of this dress of all dresses in which she would recognize herself she sometimes called it her nude dress it took new form from time to time in her dreams becoming a flying shoe or fish-scaled stockings with a seam and garters or a hat but something always remained concealed and something flashed in the dark

For now that dress was this cabin a room in white she wore it completely naked and proud in a wide cut around the shoulders and joints she felt beautiful sure of herself seductive and swaying her hips she took a few steps this way and a few steps that way a dizzying game the stakes grew larger as anyone who knows her own desires is aware of the risk

Here she was uninhibited and totally weightless even without that watchful model of diligence her own image in the mirror this was liberated territory the place beyond time and ideally suited for the silly-wise questions posed to the inner woman that were otherwise swallowed up by the day-to-day

With that the woman looks over once again to the stack of paper now glaring white like a fresh bundle of washing in the dusty midday light for usually there is dust lying here in the cabin it moves about on the draught in flakes like mouse-grey wool sealing over all of the visits of the past only where she has just been sitting a hole bleats out on the bench lies an ant and lies crushed

Now I can keep the whole mess for myself think my own thoughts to myself about the great secret of women we get our stories back with all the voices and gestures each her own burden her secret her fear her desire her guilt her longing her sleep her soft fat with all the veins tendons and nerves with all her eyes her hair her skin

The year has passed and the day right along with it the woman then stretches a line in the garden she pulls it tight and knots it skillfully between the plum and the apple trees she walks barefoot and counts her steps out loud with mouth wide open she counts to one hundred and then she hangs the paper pages out clothespin by clothespin that takes a while but she is patient she bends down and stretches up as if this clothespinning were the only thing she was capable of it is done with a certain carelessness but not without rhythm she works just as if this strangely printed washing were not hers at all and had never had anything to do with her and if that's the way it is these stories as of today are none of my business and at every border she ever crossed in them they've posted a customs officer now

She gazes at the arrangement in the garden at the confusion of lines and the way they meet and cross between the trees the leaves rustle and stir the wind rises and has already creased a few of them she looks up then to where a cloud has long since shoved itself into place for some kind of an end has to come to this year that's been prattled away Getting set on the best of the remaining spots she raises her hands and reaches for the next best drop then for the next one too but she cannot catch the others the water rains down about her and runs over her skin it is no longer as warm as she thought this country autumn rain and to keep from freezing she begins to jump up and down Slowly at first and then wilder and wilder she dances stamping thumping and thrashing the grass and the sand crunching it with her feet and the dirt spurts up over her knees she dances and does nothing else until the paper soaks soft in the rain and flies in tatters over the fence a few pages remain stuck to her body like the dress of all dresses and the rain washes the rest into the grass

ANDRÉ RIVAL

BIOGRAPHY

1967 born in Berlin

1985 graduation from high school (Abitur) in Berlin

1986 began studies in art history

at the Freie Universität Berlin

1986-1988 trained as a photographer

at the Lette-Verein Berlin

1988 awarded the Kodak Young Artists' Prize

in Photography for his free final project.

Second home in Paris

since 1988 free-lance work in Berlin and Paris

Publications

art, Ambiente, Architektur und Wohnen,

Elle, Jardin des Modes, Merian, Petra, Sibylle, Stern,

Wochenpost and Zeit-Magazin

Exhibitions

1988 Kodak Young Artists' Prize

(Photokina – Cologne)

1992 "Weinende Frauen"

(Galerie Art Communication Berlin)

1994 "Das Berliner Bad"

(Galerie Art Communication Berlin)

Awards

1988 Kodak Young Artists' Prize

ANDRÉ RIVAL

WOULD LIKE TO THANK

Ulrike Schamoni

Helga and Hans Joachim Rival
and his entire family

Thea Herold, Kristin Sauer,
Prof. Klaus Honnef, Georges Mara D'Ejove

Dr. Thomas N. Stemmle, Peter Wassermann,
Andrea Hostettler, Bernhard Bruckmann, Hans Isaak

Timo Nasseri, Vesna Pusic for make-up on the women
who requested it

Frank Thiel, Lisa Schädlich, Egbert Baqué,
Lukas Langhoff, Hartmut Jahn, Robert Jamerz,
François Cardière

and especially all of the women involved
in this project

Copyright © 1995/1996 by

EDITION STEMMLE AG, 8802 Kilchberg / Zurich, Switzerland

Photo reproduction copyright by

André Rival, Berlin, Germany and Paris, France

Text copyright by the authors

Translation: John S. Southard

Editorial direction: Esther Oehrli, Mirjam Ghisleni-Stemmle

Art direction: Grafikdesign Peter Wassermann, Andrea Hostettler,

Flurlingen, Switzerland

Photolithography by Sota Repro AG, Zurich, Switzerland

Printed and bound by Passavia Druckerei GmbH, Passau, Germany

ISBN 3-905514-45-1